Heritage

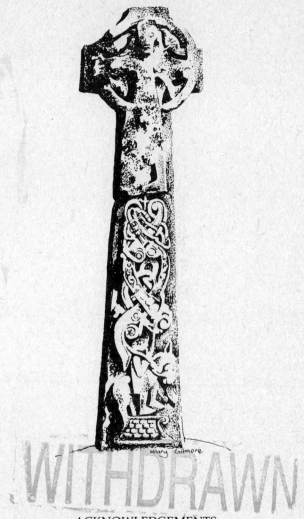

Hilary Gilmore

ACKNOWLEDGEMENTS

The publishers wish to acknowledge the assistance given by a number
of people involved in the preparation of this publication. These include
the illustrator and author Hilary Gilmore and Cian O'Carroll who
originally suggested the idea and handled the editorial work. A major
contribution was made by Liam Irwin, Head of the History Department,
Mary Immaculate College of Education, Limerick, who prepared the
chapter introductions and acted as consultant editor.

Irish Art Heritage

From 2000 BC

DESIGN LEGACY
FROM THE MID-WEST

Hilary Gilmore

A SOURCE BOOK FOR
CRAFT WORKERS

THE O'BRIEN PRESS
DUBLIN
in association with
SHANNON DEVELOPMENT

First published 1983 by
The O'Brien Press Ltd. 20 Victoria Road Dublin 6
in association with Shannon Development

©
Shannon Development

British Library Cataloguing in Publication Data
Gilmore, Hilary
Irish Art Heritage from 2000 BC
Design Legacy from the Mid-West
1. Decoration and ornaments — Ireland —
History
I. Title
745' .09415 NK1446
ISBN 0-86278-042-X Hardback
ISBN 0-86278-043-8 Paperback

Book design: Michael O'Brien and Frances Hyland
Typesetting: Redsetter Ltd.
Printing: Irish Elsevier Printers, Shannon,
Republic of Ireland.

Front cover photograph: hair ornaments,
c. 700 BC, built up of microscopic wires soldered
together. Courtesy Bord Fáilte and the Metropolitan Museum
of Art, New York. Back cover: Interior of an Irish
cottage at Bunratty Folk Park; photograph
courtesy Shannon Development.

Contents

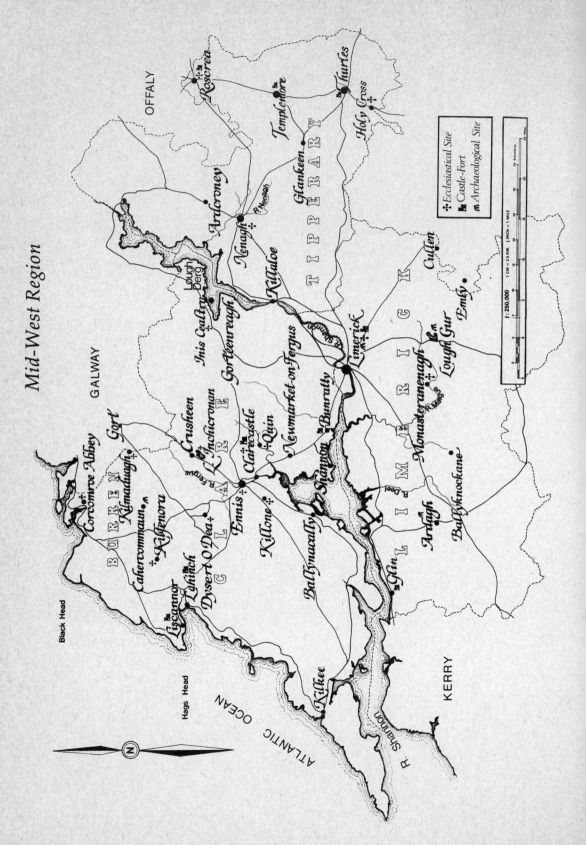

Mid-West Region

OFFALY

Roscrea

Templemore

Thurles

Holy Cross

TIPPERARY

Glankeen

Ardcroney

Nenagh

Lough Derg

Killaloe

Inis Cealtra

Gorteenreagh

Limerick

Emly

Cullen

Lough Gur

Newmarket-on-Fergus

Bunratty

Monasteranenagh

Quin

Crusheen

Inchicronan

GALWAY

Gort

Corcomroe Abbey

BUREN

Kilmacduagh

Cahercommaun

Kilfenora

Dysert O'Dea

Ennis

Killone

Clarecastle

Ballynacally

Shannon

Kilfenora

Liscannor

Lahinch

CLARE

LIMERICK

Arlagh

Ballyknockane

Kilrush

Black Head

Hags Head

ATLANTIC OCEAN

Kilkee

R. Shannon

KERRY

1 : 250,000

Ecclesiastical Site

Castle-Fort

Archaeological Site

N

6

Introduction

Since May 1978, when Shannon Development was given responsibility for the intensive promotion of indigenous industry throughout the Mid-West region (Limerick, Clare, Tipperary North Riding), the company has become increasingly involved in supporting craft activities. To date, craft projects in pottery, leatherwork, jewellery, weaving, batik work and glassware have been assisted. In order to give products made in the Mid-West region a distinctive quality, it is desirable that the designs and motifs used should, as far as possible, reflect the traditions and visual history of the region. For this reason, Shannon Development has commissioned the preparation of this design source book.

In view of the vast amount of material available, it would be unrealistic to publish a comprehensive and complete guide. Of necessity, a general approach has been adopted. However, typical examples of the rich heritage in metal, stone and other materials, dating from the pre-Christian period to the twentieth century have all been included. In addition, special sections have been allocated to folklife and plants. The choice of material does not conform to a precise, structured pattern but reflects very much the personal preferences of the author.

A major overlap exists in the evolution of art styles. Many have developed concurrently and we have examples of motifs which re-appear from time to time in modified forms. For this reason classification and general dating of material has not been approached in a rigid fashion.

The artefacts illustrated are in no sense insular; many can be traced to origins in continental Europe and the Scandinavian countries. The early Celtic and mediaeval periods are by far the richest periods of artistic achievement. Irish interpretation and craftsmanship give many of the items their special character and quality.

Some of the better known items, such as the Gleninsheen collar and the Mooghane find, have been omitted as information about these objects is readily obtainable from other published sources. In the case of fixed stone monuments, the locations are indicated in each instance. The place-names identified with metal objects and manuscripts in most cases indicate where the objects were originally found. Most of these objects are now exhibited in major national or provincial museums and libraries.

A section in this book includes suggestions about the possible use and application of the design material. The materials and tools of the particular craft in question will to a large degree determine the final result. It is hoped that craftworkers will apply their personal interpretations to the material illustrated, rather than copy any of the motifs directly. Readers are also encouraged to undertake their own research through fieldwork and by referring to the bibliography. The appeal of craft items produced will be greatly enhanced if workers include appropriate historical notes on labels, promotional leaflets, etc.

Special tribute must be paid to those whose countless fingers and minds over many centuries devised the patterns of beauty illustrated here. It is hoped that this source book will assist in maintaining these standards into our own time.

The Bronze Age

2000 - 500 BC

The first people to settle in Ireland had arrived here by 7000 BC but we have to wait at least four thousand years for evidence of any conscious artistic activity on the island. The Neolithic people decorated some of their megalithic tombs with curvilinear patterns for, it would seem, religious rather than artistic reasons. It is with the advent of the Bronze Age that art and craftsmanship can be said to begin in Ireland.

It is generally agreed that the Irish Bronze Age started around 2000 BC and lasted until 500 BC. It is normally divided into three phases: Early 2000 - 1500 BC, Middle 1500 - 1200 BC and Late 1200 - 500 BC. It has sometimes been called Ireland's first Golden Age due to the large number of gold ornaments produced. Bronze objects of a high artistic quality were also made, principally trumpets, shields, weapons and tools. Art on stone and in pottery, usually with the same patterns and motifs, is also found.

It is not clear if these developments were due to the arrival of new people: settlement sites of this period are few and information is consequently limited. Burial customs certainly did change both from the communal rite of the Neolithic to individual burial, and from the megalithic tombs to simple stone-lined cists. Whether it was an influx of new people or merely new ideas and fashions is uncertain, either way, the surviving art work shows that Ireland was in contact with large areas of northern and western Europe while further influence from the Mediterranean and the Near East is also possible. The Shannon

estuary undoubtedly provided an important access route for these various influences.

In general, Irish Bronze Age ornament is abstract and geometrical. The earliest work in gold was the manufacture of small discs from thin sheet gold. The decoration was applied by hammering out the desired shape from the back. This was usually a cross encircled by concentric bands of chevrons or dots. This repoussé technique gave way around 1500 BC to incised decoration where designs were hammered in on the front of the objects. The best examples of this work are the lunulae. These crescent-shaped neck ornaments are a uniquely Irish art form. The decoration is confined to the edges and the ends of the collar and consists of triangles, zig-zags, lozenges, chevrons and parallel lines. The Middle Bronze Age saw an increase in the manufacture of gold jewellery, particularly ear-rings and torcs. The torcs vary in size and appear to have been worn as necklaces, bracelets, anklets and girdles. Both earrings and torcs were made from gold bars which were twisted into the desired shape. The Late Bronze Age saw further development in gold working, particularly in the Shannon estuary area where the gorgets were largely made. These neck ornaments were the largest gold objects produced in this entire period. Sheet gold was hammered up into ribs and separated by lines of punched dots or rope moulding.

Bronze weapons were also decorated to a high standard. Geometric designs predominate and the axe heads are the most notable examples of this work. Shields and large cauldrons in bronze also testify to the skill of bronze craft workers. Pottery was generally ornamented with similar geometric motifs. The best examples of this are the food vessels and urns which were made to be placed in graves, either to cover the remains of the person or to hold food for the journey to the next life.

In general, while objects of great beauty were produced, the Irish Bronze Age did not exhibit great originality in its artwork. The repertoire of applied decoration remained limited to the same narrow range of geometric designs throughout the period. In particular, there was a total absence of any attempt at representational art.

The Bronze Age was succeeded by the Iron Age which saw the arrival of further artistic influences. The most notable of

these was the Celtic La Tène culture which transformed the native Bronze Age tradition and itself became merged with the great explosion of artistic activity which followed the introduction of Christianity in the fifth century AD and rose to its zenith in the eighth century with the production of objects such as the Ardagh chalice, Tara brooch and Book of Kells.

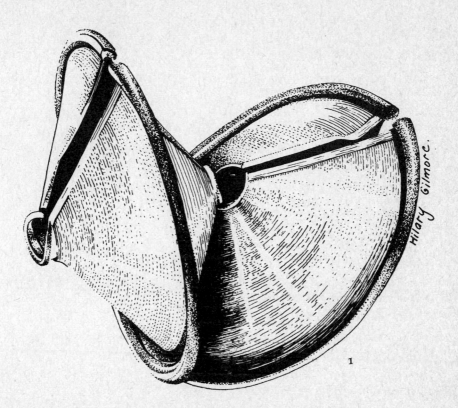

1

1 Gold Hair Rings - *Gorteenreagh, Co. Clare* - These gapped, conical ornaments date from the Late Bronze Age and are thought to have been used for holding hair in place. They demonstrate the highest skill of the early Irish goldsmith. Four main pieces are used in their construction — a circular binding strip, a central split tube, and two gapped, conical faceplates.

The gold hair rings seem to have originated in Ireland and they are most commonly found around the Shannon estuary. Examples found in Britain are similar; some were probably of Irish manufacture. Derived forms, sometimes incorporating bronze, have been found in France.

The surface of the faceplates is covered with a continuous series of minute parallel grooves which give a matt satin-sheen finish to the metal. These were apparently drawn with a compass as concentric circles. The skill needed for this was surpassed in some exceptional cases where the entire sheet was built up of fine gold wires laid side by side and soldered together to form one continuous surface.

2, 3 Various Finds - *Lough Gur, Co. Limerick* - The area surrounding Lough Gur has one of the riches concentrations of archaeological remains in Ireland. Stone Age house sites, Bronze Age ston circles, megalithic tombs, crannógs, ring forts and mediaeval castle and church ruins are all in th area. Two stone forts, Carraig Áille I and II, wer excavated and date to the Early Christian period.

Fig. 2 illustrates a ring-pin or small brooch of gilt bronze with traces of gilding remaining in the deeper portions of the interlacing. The pin shows signs of being tinned. It was probably made in the eighth or ninth century.

Fig. 3 depicts a bronze, enamelled hand-pin, bent but complete. It bears a design in red champlevé enamel. The outside curved edge of the pin-head bears a deeply incised herring-bone design which was filled with red enamel. The seventh or at latest eighth century is suggested as the date for this hand-pin found at Carraig Áille II.

4 Bronze Shield - *Lough Gur, Co. Limerick* - The earliest shields found in Ireland date from the Late Bronze Age. They are circular, made of leather, wood and bronze, all alike in having a hemispherical boss ringed by the same concentric mouldings which appear in the decoration of gold ornaments.

The Lough Gur shield, *c.*700 BC, is a rare bronze specimen. It consists of a very thin bronze plate on which six equally-spaced concentric ridges were raised. Between the ridges are six rings of raised hemispherical bosses. This illustrates the genius of the draughtsman who combined artistic originality with the practical function of making the shield more effective in withstanding blows from a sword. It is probable, however, that this unusual example was kept mainly for ritual or ceremonial use.

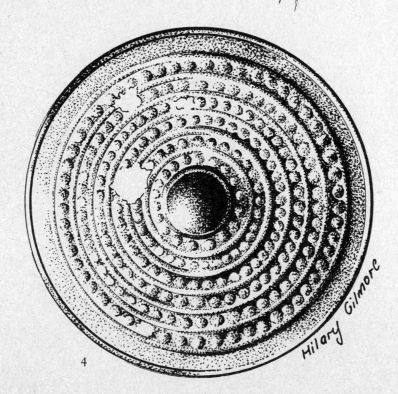

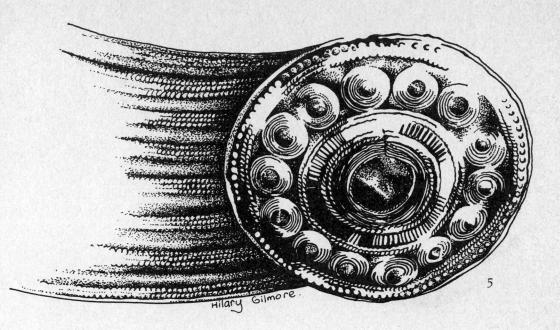

Hilary Gilmore.

5

5 Gold Gorget - *Ardcroney, Co. Tipperary* - The gorgets, or gold collars, were the largest individual gold objects made during the Irish Bronze Age. They have all, with a single exception, been found in the Shannon estuary region and, while unique to Ireland, show some influence in design from southern Scandinavia. The most famous example, the Gleninsheen collar, has been termed the ultimate artistic achievement of Ireland's first Golden Age and the example shown here is broadly similar to it in style.

Seven strongly-defined parallel ribs are divided by six bands, each decorated with lines of rope moulding. The inner and outer edges and the ends are slightly decorated with two bands. The body has a crossridge at each end and beyond this a tongue of plain metal. On such gorgets the terminals are composed of an upper and lower convex circular plate, linked by folding the edge of the lower plate around that of the upper.

Early Christian Era

5 - 10TH CENTURY

Bronze was gradually replaced by iron as the main metal from
c. 500 BC and this important change coincided with the arrival
of a Celtic warrior élite. The Celts appear to have dominated
the country within a relatively short period and to have fully
imposed their language and culture on the entire population.
The Celtic smiths and craft workers, while introducing their
own designs and techniques, did not ignore the existing tradi-
tion and a fusion of both elements is apparent. The distinctive
Celtic contribution was the La Tène style, called after a site in
the central European homeland of the Celts. Despite the avail-
ability of the superior iron metal, it was largely on the tradi-
tional materials of gold, bronze and stone that La Tène decora-
tion was applied.

Roman influence also spread to Ireland in this period. While
the Romans never conquered Ireland, their presence in Britain
inevitably led to contact. A large quantity of Roman objects
found its way to Ireland and gave local craft workers the oppor-
tunity to imitate and adapt some of the Roman designs and
techniques, particularly in metalwork and the use of enamel.
The Irish penannular brooch, represented here by the Ardagh
and Roscrea examples, is basically derived from a Roman
prototype. The most profound influence from Roman Britain,
however, was the mission of St Patrick.

The introduction of Christianity brought new and diverse
influences but its greatest contribution was the change it
brought in the patronage of art. The Christian monasteries

were the agents of the remarkable development and achievement which culminated in the Golden Age of Irish art.

The art of Early Christian Ireland can be divided into three phases. From the fifth to the middle of the seventh century we see the beginning of the new style. The amount of material which survives from this phase is limited — mostly brooches, dress fasteners and pins in gilt or silvered bronze decorated with glass and enamel. The ornament is usually confined to very small surfaces, and a similar approach can be seen on manuscripts with only the capital letters decorated. From the mid-seventh to the early eighth century a dramatic development occurs which is highlighted particularly in manuscript illumination and sculpture. The art reaches its zenith in the eighth and ninth century when technical perfection was allied to breathtaking skill and virtuosity in decoration. Metalwork, sculpture and manuscript illumination developed with equal brilliance, producing masterpieces in each medium. Artistic patterns then established still form part of our ethos.

This art is almost wholly non-representational, exhibiting a vast repertoire of abstract patterns. On the rare occasions when humans or animals are portrayed, little attempt is made at anatomical accuracy. People are presented through their clothes rather than their bodies while animals are usually exotic and imaginary creatures. The real interest of the artists is in abstract motifs, spirals, triskele, trumpet patterns and interlacing of extreme variety and inventiveness. Only a fraction of what was produced in this remarkable age remains. Much of the work appears to have been executed on textiles, leatherwork and wood, and has not survived due to the perishable nature of these materials. Nevertheless the metalwork, stone and manuscripts which we are lucky to possess show the unique and unparalleled nature of this artistic flowering.

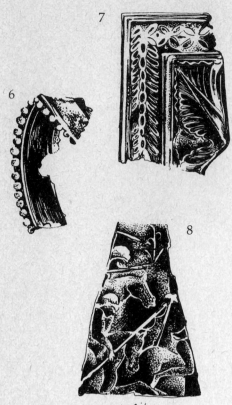

7

6

8

H. Gilmore

6-8 Roman Remains - *Balline, Knocklong, Co. Limerick* -Late Roman metalwork influenced Early Christian Irish art – notably Irish hanging bowls – and such influences were confined mainly to the east coast. However, in 1940, a hoard of fifth-century Roman style items was found at Balline in Co. Limerick. The find consisted of two silver ingots, parts of two others and three fragments of silver plate which are shown here.

The piece shown in Fig. 8 depicts a hunting scene in which the horses are particularly well drawn. These figures were apparently cast on the plate, and subsequently outlined with sharp cutting tools. Roman remains have been discovered also in other locations: Lough Gur, Golden, Buttevant and Urlingford.

9 Runic Inscription - *Killaloe Cathedral, Co. Clare* - This stone contains the only runic inscription as yet found on the mainland of Ireland. It probably dates to the first half of the eleventh century. Its inscription reads, 'Thorgrim raised this cross.'

It is clear that the stone is part of the right arm of a cross, the outline of which is shown in Fig. 10. The opposite arm probably had a continuation of the inscription, possibly the name of the person in whose memory the cross was erected and their relationship to Thorgrim.

The Killaloe stone has been compared with one at Kilbar on the island of Barra (Scotland), bearing a cross and a runic inscription in which Ur and Thur, who erected the monument, invoke the favour of Christ on the soul of the deceased.

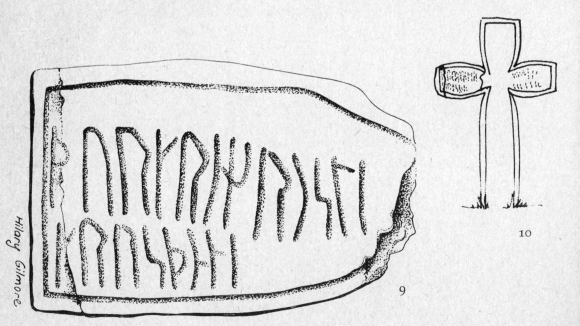

Hilary Gilmore

9

10

11 Silver-Gilt Thistle Brooch - *Ardagh, Co. Limerick* - This type of penannular silver thistle brooch was common in the tenth century (Hiberno-Viking period, silver phase).

The head of the brooch is formed by a silver-gilt ball, pierced horizontally to allow the ring to pass through. The head is topped by a low disc decorated with two concentric incised circles. The brambled decoration is cast. The silver-gilt balls at the ends of the ring are similar to the one on the head.

12 Ardagh Chalice, Base - *Ardagh, Co. Limerick* - The Ardagh chalice, an early eighth century communion chalice, found in 1868, is regarded as the greatest masterpiece of the era. It is a round-bottomed, silver bowl with a short stem and conical foot with a flat flange, and it has loop handles. It is decorated with gold filigree and red and blue enamel.

The underneath of the base is also decorated and a portion of it is shown here. At the centre is a circular crystal (a); next to the crystal is a circle of amber divided into twelve tablets by bronze divisions (b); next to the amber is a circle of gold filigree and a tablet of amber which has fallen out (c); finally there is a circular bronze plate, which is highly carved and gilt, on which are fine enamels in green.

The extreme outer edge (not illustrated) is like the reverse side of the base and is divided into eight spaces in which are eight pieces, six in silver, two in copper. Two of the silver pieces are of beautiful plaited wire work.

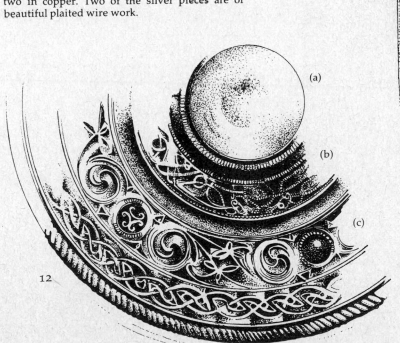

11

(a)

(b)

(c)

12

14

15

13

Hilary Gilmor

13-15 Silver, Penannular Brooch - *Ardagh, Co. Limerick* - The pinhead of this ninth-century brooch is rectangular with a central panel of the same shape bordered by rope moulding. Within the moulding is a rhombus with concave sides which originally held a decorative plate. Animals are contained at the corners, their bodies bent at right angles.

The top of the pin is fitted into a melon-shaped, ridged protuberance. The cylindrical pin carries elongated rhombuses front and back, below the terminals. Three narrow straps unite the sides of the plate. There are concave, pointed oval designs at the corners of the plate. A central trapezoid is bordered by rope moulding. Above is a bird with a reflexed head (fig. 14), while fish-like creatures appear below (fig. 15).

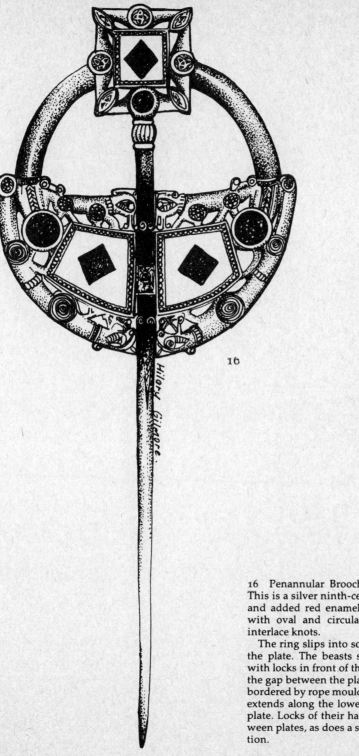

16

16 Penannular Brooch - *Ardagh, Co. Limerick* -
This is a silver ninth-century brooch with gilding
and added red enamel. It has a square pinhead
with oval and circular cells containing simple
interlace knots.

The ring slips into sockets in the top corners of
the plate. The beasts shown are highly stylised
with locks in front of their eyes meeting to bridge
the gap between the plates. Central trapezoids are
bordered by rope moulding. Another animal body
extends along the lower margin of each terminal
plate. Locks of their hair also bridge the gap bet-
ween plates, as does a strap with interlace decora-
tion.

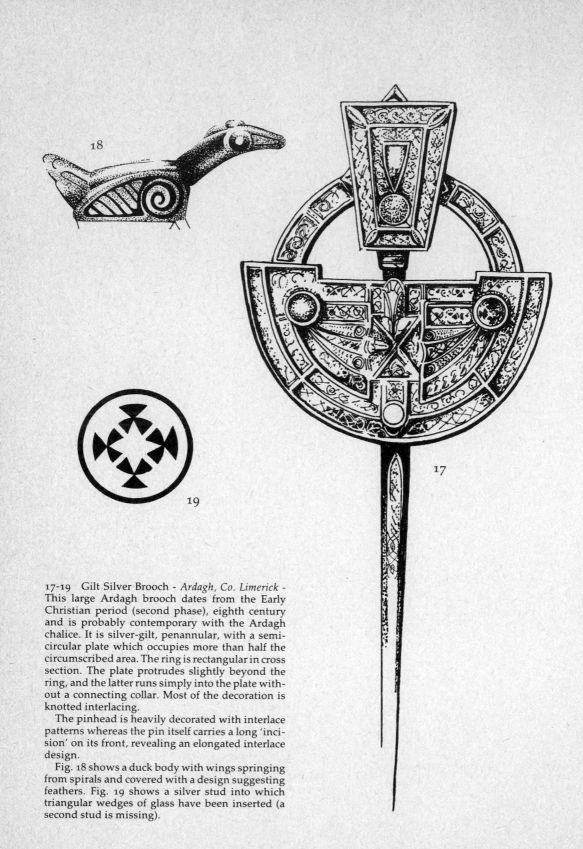

18

19

17

17-19 Gilt Silver Brooch - *Ardagh, Co. Limerick* -
This large Ardagh brooch dates from the Early
Christian period (second phase), eighth century
and is probably contemporary with the Ardagh
chalice. It is silver-gilt, penannular, with a semi-
circular plate which occupies more than half the
circumscribed area. The ring is rectangular in cross
section. The plate protrudes slightly beyond the
ring, and the latter runs simply into the plate with-
out a connecting collar. Most of the decoration is
knotted interlacing.

The pinhead is heavily decorated with interlace
patterns whereas the pin itself carries a long 'inci-
sion' on its front, revealing an elongated interlace
design.

Fig. 18 shows a duck body with wings springing
from spirals and covered with a design suggesting
feathers. Fig. 19 shows a silver stud into which
triangular wedges of glass have been inserted (a
second stud is missing).

20

20, 21 Bell-Shrine - *Glankeen, Co. Tipperary* - The original appearance of this shrine (now in the British Museum) is difficult to establish as it is broken and the surviving fragments are now fixed on the bell itself. It probably consisted of four sheets of bronze held at top and bottom by cast bronze mounts. Only one of these plaques has survived; it bears an engraved cross with enlarged ends similar to those found on many funerary slabs of the same period. The upper mount, which covered the handle, now lost, and the upper part of the bell, is in a good state of preservation. It is a piece of cast bronze decorated with gold, silver and enamels.

On each side are two superimposed monster heads with a human head in full relief above the upper one (see detail, fig. 21). Between the heads runs a knotted pattern of animal foliage and in the middle of each side there is a large openwork palmette with several kinds of insect, silver ribbon niellos and plaits of brass and silver.

21

22 Shrine - *Emly, Co. Tipperary* -The Emly shrine is so called because for centuries it was in the possession of Lord Emly of Co. Limerick. The late eighth-century shrine was made to hold sacred relics. It is constructed of yew wood, and its surface has a network of open, geometric, step-like patterns inlaid directly on it in silver.

The unusual repeating geometric pattern carpets the surface, except for the medallions with deep green, yellow and dark green-brown *cloisonné* enamels. A ridge pole which terminates in two fantastic biting animal heads surmounts the roof. In the centre of the ridge is a miniature knob repeating the shape of the shrine itself.

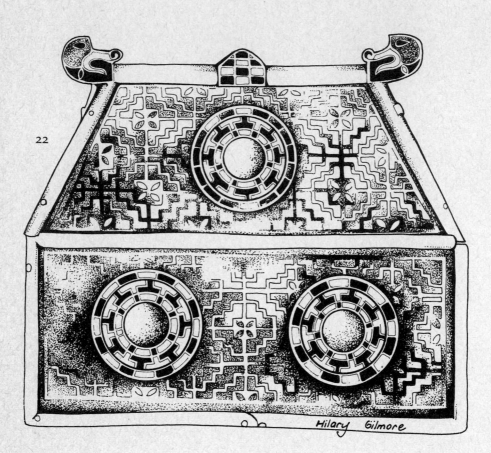

22

Hilary Gilmore

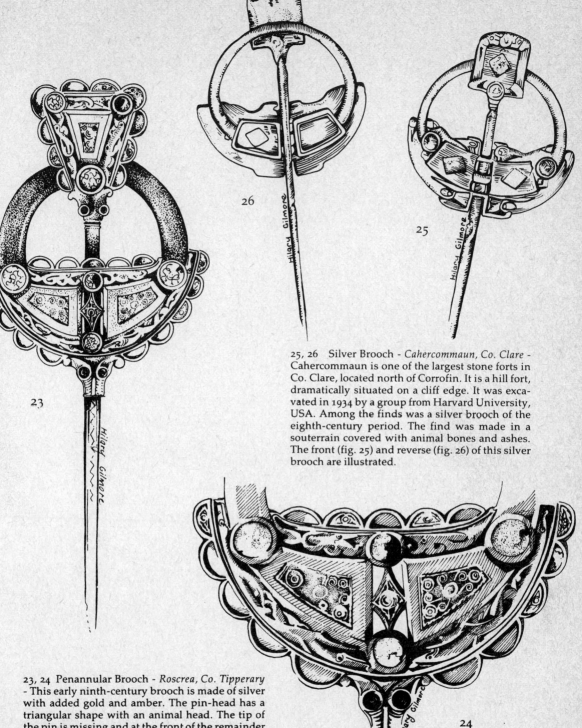

25, 26 Silver Brooch - *Cahercommaun, Co. Clare* -
Cahercommaun is one of the largest stone forts in
Co. Clare, located north of Corrofin. It is a hill fort,
dramatically situated on a cliff edge. It was exca-
vated in 1934 by a group from Harvard University,
USA. Among the finds was a silver brooch of the
eighth-century period. The find was made in a
souterrain covered with animal bones and ashes.
The front (fig. 25) and reverse (fig. 26) of this silver
brooch are illustrated.

23, 24 Penannular Brooch - *Roscrea, Co. Tipperary*
- This early ninth-century brooch is made of silver
with added gold and amber. The pin-head has a
triangular shape with an animal head. The tip of
the pin is missing and at the front of the remainder
of the pin is an incised chevron design.

An illustration of the plate (fig. 24) shows that
it is broader than the semicircular ring. Amber
bosses interrupt a band of tubular animals. Gold
filigree plates occupy the trapezoidal areas.

Hiberno-Romanesque Period

11 - 12TH CENTURY

The great Golden Age of Irish art and craftsmanship in the seventh and eighth centuries declined during the following two hundred years. The Vikings are no longer seen as the sole cause of this: secularisation of the Church, changes in society and increased warfare are nowadays also recognised as contributing factors. This decline was reversed in the eleventh and twelfth centuries when artistic output was revived. Ironically the Vikings, at this stage Christianised and fully integrated into Irish society, made an important contribution to the renaissance. Irish metalwork provides a very good example of this trend. Some excellent work, equal to that of the earlier period, was produced using many of the older techniques but also incorporating Viking influences. In decoration, Scandinavian animal patterns are the most notable feature. The shrine of the crozier of the abbots of Clonmacnoise illustrates this borrowing in both style and technique. It has Scandinavian animals formed of inlaid bands of silver bordered by niello, which was a direct borrowing by Irish metalworkers from Viking craftsmanship. Geometrically designed panels with enamel and filigree, typical of the Irish metalwork tradition, are frequently found in conjunction with the interlaced animal design. The two masterpieces of the amalgam from this period are the cross of Cong and St Manchan's shrine.

In stonework, the high crosses of the period show distinctive changes from the Early Christian examples. Biblical scenes are no longer carved on the shaft but are replaced by a large figure

carved in high relief. This figure usually represents an abbot or bishop, while the figure of Christ often appears on the opposite face of the shaft. Panels of geometric and interlacing design are also found with an occasional example of Scandinavian influence. The Hiberno-Romanesque period is characterised above all by its architecture. Ireland was very late in adopting the Romanesque style of building. In Europe it was popular from the late eighth century onwards, at least in its basic outline of a church with a nave and side aisles, a round apse at the east end and possibly transepts to provide a cruciform plan. By the eleventh century the distinctive decoration of the Romanesque had been developed with its elaborate use of the chevron or zig-zag motif. Cormac's chapel on the Rock of Cashel, built between 1127 and 1134, is generally regarded as the introduction of the new style to Ireland though it is, in many respects, untypical. Most of the other Irish Romanesque churches which followed were only interested in, or capable of borrowing, individual features from it.

In most cases, Irish stonemasons confined themselves to using Romanesque decoration on doorways and chancel arches. Irish churches generally lacked arcades between the nave and aisles so that no capitals were available for decoration. No attempt was usually made to decorate the windows. The chevron was the most popular motif employed in Irish Romanesque carving, often being used with great variety and ingenuity. Individual carved heads, particularly of animals, are another feature, with some examples showing, yet again, Scandinavian influence. A close relationship with metalwork decoration can also be seen in the use of a flat incised ornament of foliage, fretwork and interlace.

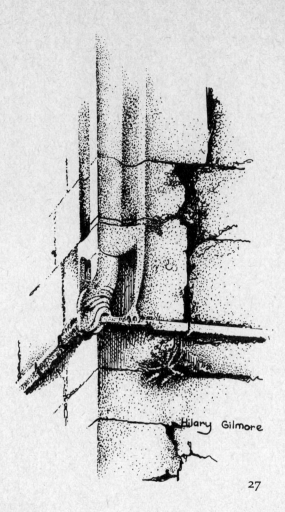

Hilary Gilmore

27

27-30 Items from Cistercian Abbey - *Corcomroe,
Co. Clare* - Corcomroe is a Cistercian abbey foun-
ded by the O'Briens between 1175 and 1195 for
monks from Inishlounaght near Clonmel. On the
east gable of the church there are three lancet win-
dows. Above these is a single lancet window and a
further window above the vaulting giving light to
a room above the chancel which cannot be seen
from inside the abbey. All five windows are
pointed, exhibiting the Gothic influence which is
cleverly blended with the Romanesque touch in
the form of cornershafts. Each shaft rises from a tri-
ple plinth as its base and then tapers off to a point.
A little further up it starts again rising out of an
animal carving (fig. 27) which appears to carry the
shaft from the string course to the top of the wall.

Fig. 28 shows a detail from a carving in the cros-
sing which may have had its inspiration from the
bluebell, illustrated here (fig. 29). Fig. 30 also has a
floral inspiration — perhaps water avens or
harebells which grow in the area.

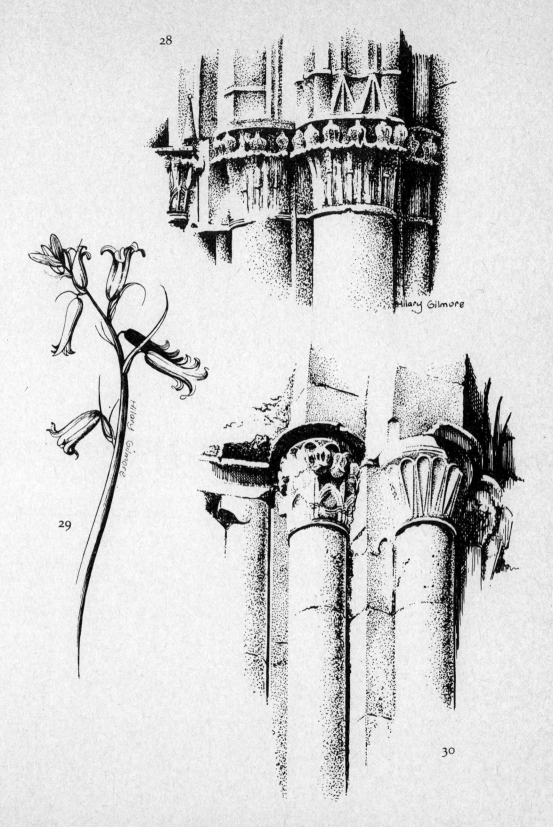

28

Hilary Gilmore

Hilary Gilmore

29

30

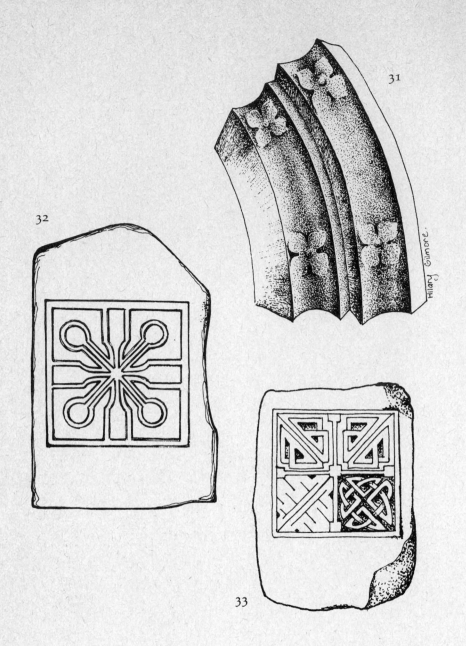

31

32

33

31 Doorway Section - *Killone Convent, Clare-castle, Co. Clare* - Killone, Co. Clare, was an Augustinian nunnery, whose foundation was ascribed to Donal Mór O'Brien, King of Thomond. It was founded around 1180 and is located on a pleasant lakeshore site. It is one of the few remaining old Irish foundations for nuns. A section from a doorway with flower details is shown.

32-34 Items from Monastic Settlement - *Inis Cealtra (Holy Island), Scarriff, Co. Clare* - Inis Cealtra, known in modern times as 'Holy Island',

lies in Scarriff bay, an inlet of Lough Derg. Accessible by boat from Mountshannon, it contains five ancient churches, a round tower, a saints' graveyard, a hermit's cell and a holy well. Fig. 32 shows an eighth-century-type stone bearing a Greek cross which has four lines within a square of two lines; four-line diagonals are stopped by two-line circles in the cantons of the cross. The angles of the cross are hollowed and all joints are mitred. Fig. 33 shows an eighth-century-type slab-stone bearing a Greek cross in a square. There are small square expansions at the centre and at the ends of the

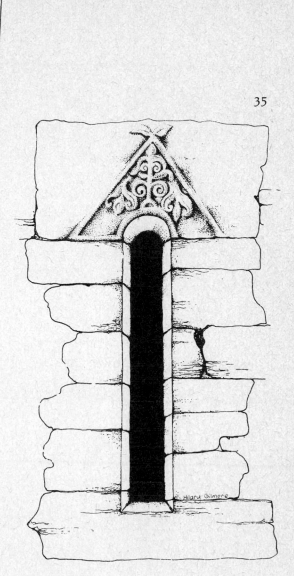

arms. In the cantons are key-patterns of simple type, except in one where there is an interlaced pattern. Fig. 34 is identified as a mediaeval and Early Modern monument; it may be late fourteenth century. It is a complete but much worn slab. It bears a cross, with expanding circular centre, having a rosette with the unusual number of nine lobes in the middle; floral patterns fill the angles of the cross. In the base of the slab is a square panel with a four-leaved flower.

35 Abbey Window - *Inchicronan, Crusheen, Co. Clare* - Inchicronan is an Augustinian abbey on the narrow lake promontory near Crusheen, Co. Clare. It stands on an earlier monastic site founded by St Cronan. The abbey was granted to canons from nearby Clare Abbey in 1189 by Donal Mór O'Brien.

The east window, shown here, has beautiful foliar decoration on the outside. Its style suggests a twelfth-century date.

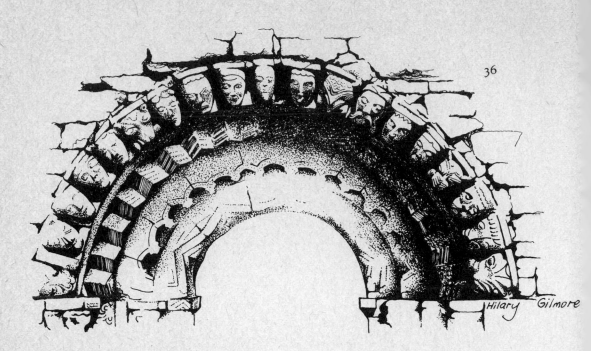

36

36-38 Items from Monastic Site - *Dysert O'Dea, Co. Clare* - The monastery at Dysert O'Dea was founded by St Tola in the eighth century. It is situated six miles from Ennis, close to Corrofin. It contains a round tower, a high cross, and the remains of a mediaeval church with a particularly beautiful Romanesque doorway. This doorway was re-inserted into the south wall of the much-altered church. It has four orders with geometric and foliar motifs and striking human heads. There is strong Norman influence on the design shown by scalloped capitals, chevrons, dog teeth and chains of lozenges.

Fig. 36 shows the portal carved with twelve strange human heads (one with a long moustache). Fig. 37 shows zig-zag detail from the doorway. Fig. 38 shows a detail from the church window.

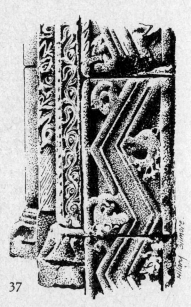

37

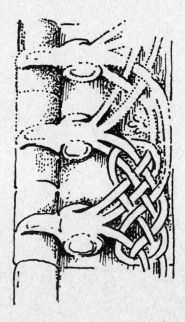

38

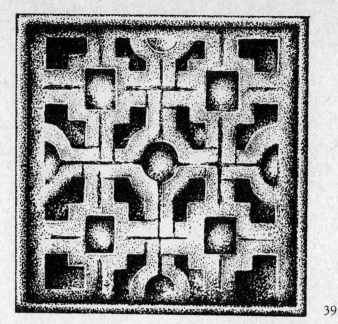

39-41 High Cross - *Dysert O'Dea, Co. Clare* - The cross at Dysert O'Dea is said to date from the second quarter of the twelfth century. On the front of the cross are two high relief figures. An embroidery-like feeling for design is evident on the remaining part of the cross.

Fig. 39 shows a step pattern combined with interlacing, with some of the centres modified to a circular form. The union of fret and interlacing is unusual. In fig. 40 an effective step pattern is arranged in a continuous or repeated form. It is curious that each centre of the right-hand side row of lozenge-shaped figures is in relief, while those of the other rows are sunken. The same design approaches have been used for both metal and stone work. Patterns on the Emly shrine illustrate this point. Fig. 41 is a floral motif from the Dysert O'Dea cross.

The Mediæval Period

12 - 16TH CENTURY

The arrival of the Normans in the mid-twelfth century forms a convenient dividing line between the Hiberno-Romanesque and the mediaeval periods. The Norman conquest and expansion up to the mid-thirteenth century and the Gaelic revival of the following two centuries left a lasting mark on architecture and artistic activity. Norman influence was most profound in architecture, both in the castles they erected and in the ecclesiastical buildings they patronised. Beginning with the motte and bailey defences, the Normans soon advanced to erecting circular stone castles with massive curtain walls based on models then popular in England. The tower houses were erected in the fifteenth and sixteenth centuries, again following a European trend of building smaller castles. The tower house was usually four or five storeys high with a gabled roof and was surrounded by a walled defensive bawn. The Gaelic Irish as well as the Anglo-Normans built this type of castle. In church architecture the Norman contribution was the Gothic style. The erection of parish churches, abbeys and friaries occurred in two phases: an initial burst of activity in the thirteenth century, followed by a second phase in the fifteenth century.

In metalwork the main activity for which we have a record is the repair of older objects. The bell shrine of St Senan from Scattery island was given a completely new outer cover of gilt silver plate. The decoration is incised and the motifs are animal representations surrounded by stylized foliate ornament. The flat incised technique was not the only one in use, as is shown on

book shrines decorated with human figures in relief. The O'Dea mitre and crozier are the best examples of original work in metal in this period.

The most popular form of sculpture in mediaeval Ireland was tomb sculpture. The Norman knights and bishops were keen to have effigies of themselves over their burial places. These were modelled largely on English sculpture of the period and some may even have been imported already carved. The Black Death in the fourteenth century affected the production of sculpture, as it did so much else in the artistic field, but sculpture was revived in the late fifteenth century particularly by the Plunkett family of the Pale. Figure sculpture was also produced for baptismal fonts and occasionally for wayside crosses. The best examples of both survive in Co. Meath.

The few surviving examples of wooden statues do not indicate any great technical or artistic achievement. The Brian Boru harp in Trinity College shows the continuation of the use of interlacing and animal motifs not alone in metal but also in wood. In one context, however, Irish expertise in wood carving was on a par with anything England or Europe had to offer. This can be seen in the fifteenth-century misericords of St Mary's Cathedral in Limerick. The carvings of animals on these cathedral seats illustrate a very high level of skill.

The troubled political history of the succeeding seventeenth century, with its rebellions, repressions, religious wars, confiscations and plantations, has resulted in very little evidence surviving of the artistic life which existed. In the absence of essential raw material, no coherent statement about the period can be made.

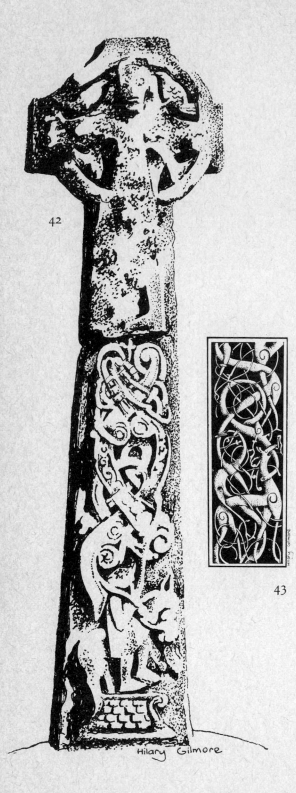

42

43

Hilary Gilmore

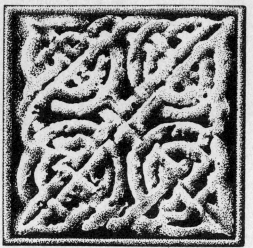

Hilary Gilmore

42-44 High Crosses from Monastic Site - *Kilfenora, Co. Clare* - The cathedral at Kilfenora was built on the site of a monastery founded by St Fachtna. The cathedral was erected at the end of the twelfth century and its surviving chancel contains many interesting features. The three-panelled east window was probably made by the same master mason who worked on the cathedral at Killaloe. The capitals of the piers in this window are of scalloped form with little crockets in the intervals and carvings of four human heads on the southern piers. To the west of the church is the twelfth-century Doorty high cross, so called because part of it marked the Doorty family grave, with its figure carvings and Scandinavian-style decoration.

Figs. 42 and 43 indicate similarities in style between Irish and Scandinavian carving. Fig. 42 shows the west face of the Doorty cross with a crucifixion scene on the upper panel and underneath Christ entering Jerusalem with the Scandinavian design pattern above it. Fig. 43 is a detail from an eleventh-century church in Urnes, Norway, which has given its name to this particular art style of elaborate interlaced beasts. Fig. 44 is an intricate piece of triangular interlacing from the north cross in the graveyard at Kilfenora. The main division is into four parts but the whole surface is also divided into sixteen small triangles each containing a knot. The knots at each corner are connected by circular loops which pass twice round.

45

45-54 Franciscan Friary - *Ennis, Co. Clare* - Ennis
'Abbey' was founded in 1241 by King Donough
Cairbreach O'Brien on Calf Island (at that time
Ennis was a small island surrounded by the river
Fergus and by marshy countryside.) Much altera-
tion and rebuilding took place subsequently.

The plain, but imposing, east window is one of
the finest in Ireland and the only part still remain-
ing from the original building.

The carving of a lady in mediaeval dress (fig. 46)
is from the original McMahon tomb *c.* 1470, which
was reconstructed in the 1843 Creagh monument.

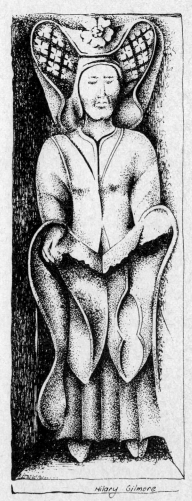

47

46

Hilary Gilmore

48

49

Fig. 47 shows the Inchiquin tomb. Figs. 48, 49, 50, 51, 52, 53 are details from the Inchiquin tomb which is opposite the Creagh tomb. The beautiful naturalistic carvings of wild flowers are under the canopy of the tomb. These carvings include leaves of ivy, buttercup, crane-bill and mallow, and flowers of mallow, wild rose and pink flowering rush.

50

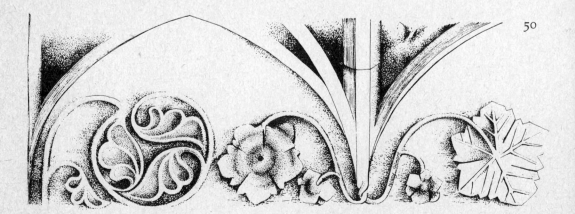

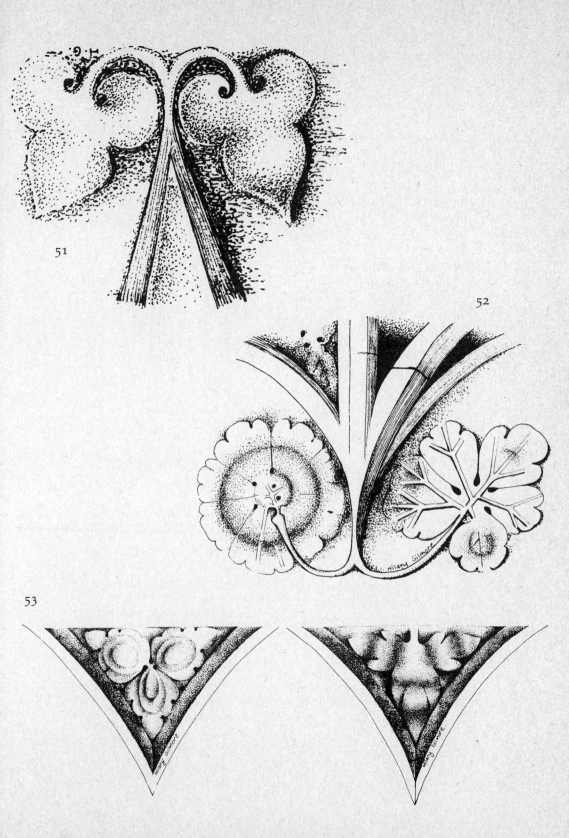

51

52

53

Fig. 54 shows a mediaeval sculpture of St Francis over the side altar of the nave. St Francis of Assisi died in 1226 before the order which he founded established itself in Ennis.

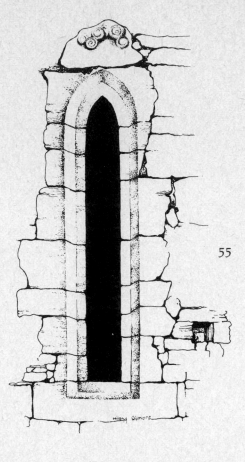

55

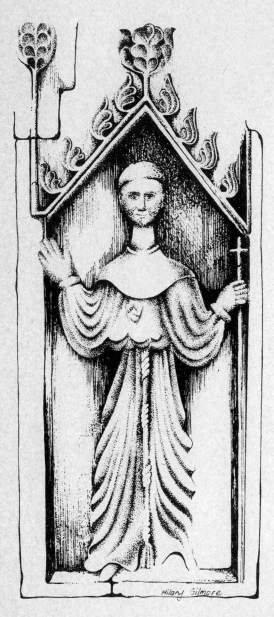

54

55-58 Items from Clare Abbey - *Ennis, Co. Clare* - Clare Abbey is an Augustinian abbey founded in 1189 and situated 1½ miles south east of Ennis. It was renovated in the fifteenth century and many of the existing buildings date from this period. The abbey was inhabited until *c*. 1650. Several interesting windows have been incorporated in the building, some of which are illustrated here. Fig. 55 shows a twelfth-century window with carved detail above. This window bears a remarkable similarity to the east window at Inchicronan, which was built the same year. Fig. 56 depicts a fifteenth-century traceried window with hood ending in a human head and carved flower detail. Fig. 57 is a fifteenth-century chancel east window with head detail. Fig. 58 shows a fifteenth-century flamboyant tracery window.

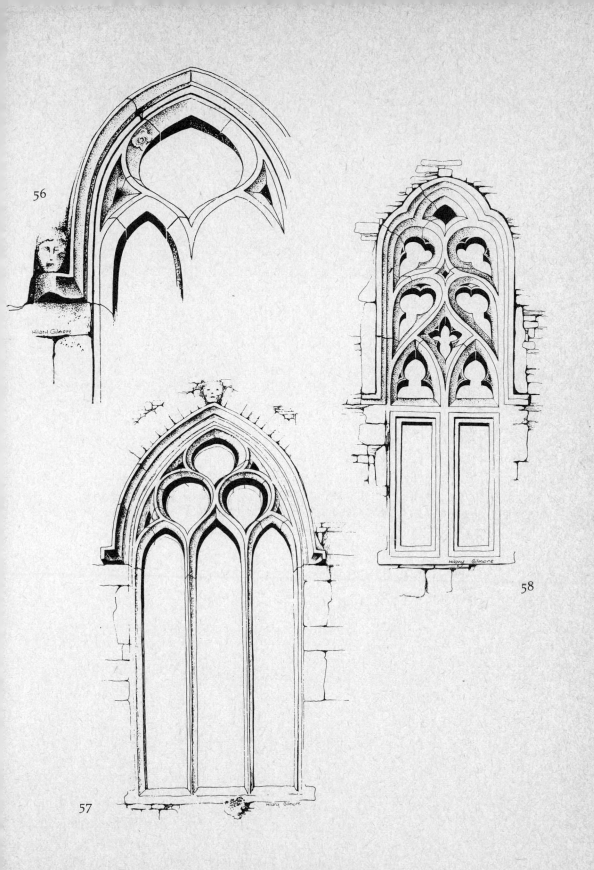

56

57

58

MEDIAEVAL PERIOD 39

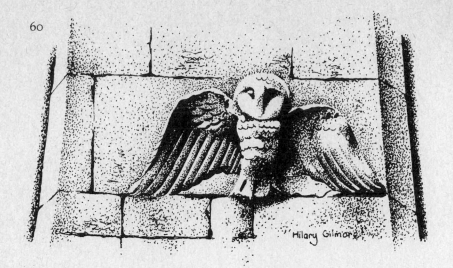

59, 60 Cistercian Abbey - *Holycross Abbey, Co. Tipperary* - Holycross Abbey is situated due south of Thurles on the west bank of the river Suir. It was founded in 1169 for the Benedictines by Donal Mór O'Brien, King of Thomond. In 1182 the abbey was transferred to the Cistercian order. Most of the surviving structures, however, date from the period 1450-75. Extensive restoration has been carried out in the past few years, and the abbey is now being used as a parish church.

Fig. 59 shows a detail from a carved side panel of a structure with columns and arches in the south transept; it dates from about 1450 and is popularly known as the 'waking place' of the monks. It was probably erected to house the relic of the 'true cross' from which the abbey gets its name. Fig. 60 shows an owl with outstretched wings. It seems about to fly out of the great north pier. Other carvings are to be seen here in random positions, almost at the whim of the masons. Some are lifelike and strikingly natural while others are gentle caricatures.

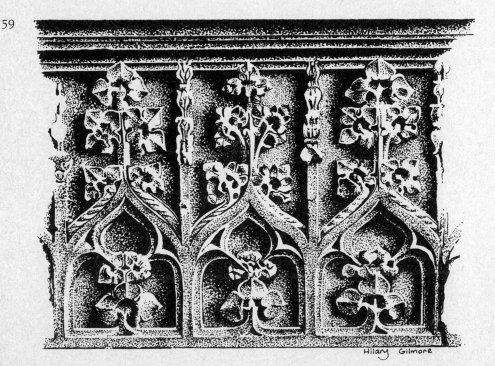

59

61, 62 Misericords and Grave Slab - *St Mary's Cathedral, Limerick* - St Mary's Cathedral was built between 1180 and 1190 by Donal Mór O'Brien on the site of his own palace.

Parts only of the Romanesque west doorway and of the nave and parts of the aisles and transepts survive from this period. The chancel and the chapels were added later, as were many of the windows. Much restoration work has been carried out since the early nineteenth century.

The cathedral, built of grey stone quarried in Co. Limerick, stands on an elevated site beside the river Shannon facing English Town, the most ancient of the three divisions of the city of Limerick. The cathedral has a wealth of ornamentation which includes beautiful windows, stonework, fine carvings and metalwork.

The carved misericords are unique in Ireland. These twenty-three black oak choir stalls were carved for the cathedral around 1489. They comprise a spectacular collection of grotesque animals and figures, many of them taken from mediaeval bestiaries such as the manticore, lion, wyvern, amphisbaena, wild boar, lindworm and griffin. Fig. 61 shows carvings from a misericord. Fig. 62 is the ancient stone slab which marked the grave of the founder, Donal Mór O'Brien who died in 1194.

63 Capital from Cistercian Abbey - *Mainistir, Co. Limerick* - Mainistir (or Monasteranenagh) was founded between 1148 and 1151 by the O'Briens, who brought monks from Mellifont, Co. Louth. The church dates from the period 1185 to 1205. Its most notable feature is the well-preserved foliate capitals particularly of the crossing. Carved in red sandstone, they look remarkably fresh and new due to non-interference until recent times.

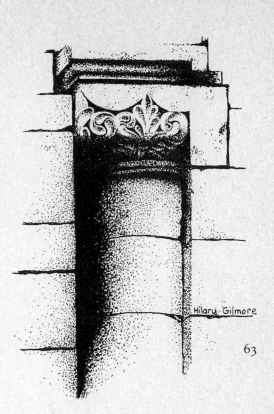

63

61

62

64

64-66 Items from Franciscan Friary - *Quin Abbey, Quin, Co. Clare* - The Franciscan Friary at Quin was erected in the early fifteenth century on the site of a castle built by the Norman, Thomas De Clare in 1280. It is a remarkable example of the skill of the stone masons who used the pre-existing castle walls to create a beautiful and complete series of friary buildings. The church has a tower, well-preserved east and south windows, five altars in perfect condition and many fine tombs.

On the south wall of the choir are some remains of an interesting piece of stucco work, representing the crucifixion with the holy women and an attending angel, over which the Sacred Heart was displayed. Similar stucco work can be seen in Bunratty, both possibly done by the same artist.

Quin has one of the best-preserved examples of a Franciscan cloister. Fig. 64 depicts a detail on one of the pillars; fig. 65 is a fine window above the cloister and an exterior window with foliar details built around 1402 is illustrated in fig. 66.

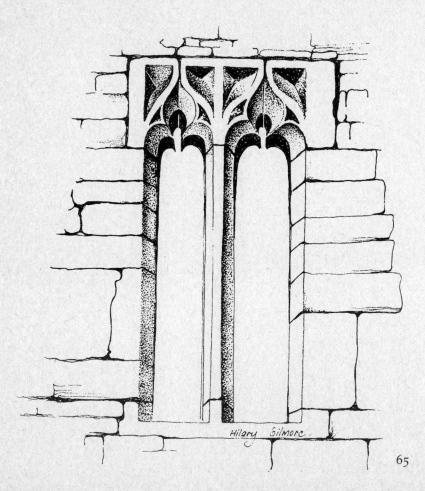

65

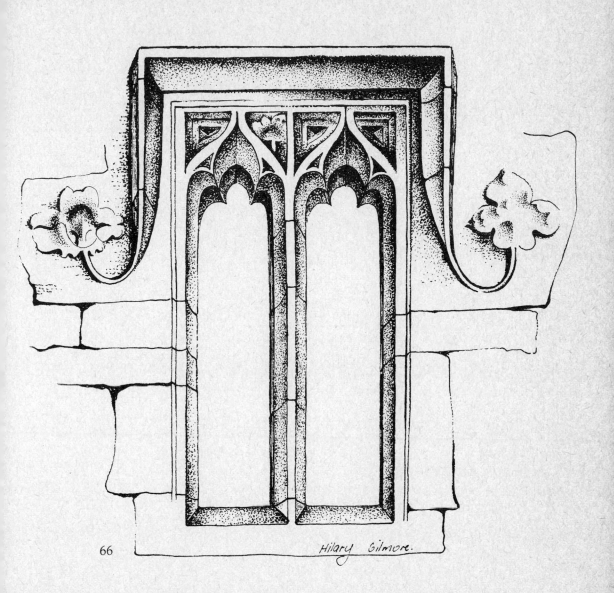

66

Hilary Gilmore.

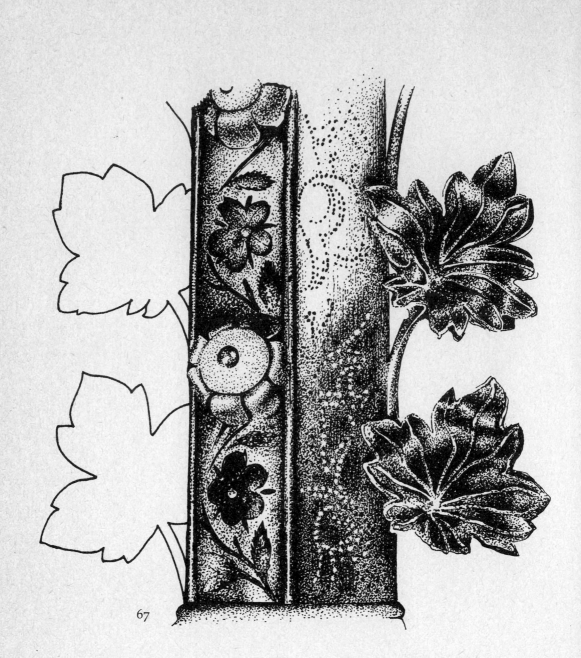

67

67-69 O'Dea Crozier - *Limerick, St John's Cathedral* - This silver-gilt crozier, made for Conor O'Dea, Bishop of Limerick (1400-26), is the only surviving example of a mediaeval Irish crozier.

This superb example of Irish metalwork in the later Middle Ages was made by Thomas O'Carryd in 1418. It is of the normal mediaeval continental form based on the shepherd's crook and consists of two parts: the staff and the decorated head which is the crook.

Fig. 67 shows a detail of the crook with pointilli decoration and enamel; Fig. 68 shows details of the inscribed and enamelled shaft. The staff is covered with an all-over pattern of interlaced vine stalks with foliage and flowers in the intervening spaces (enlarged detail illustrated (a)); fig. 69 shows the complete crozier.

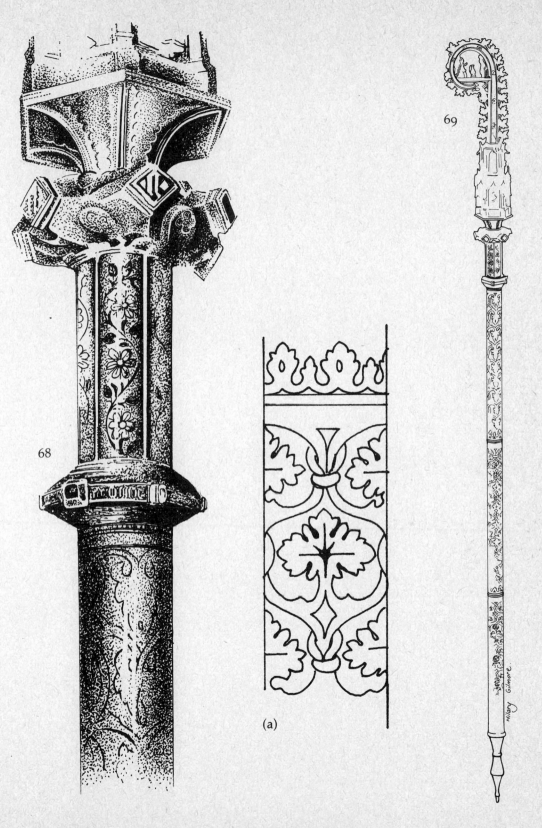

68

69

(a)

Hilary Gilmore.

70 Carved Table - *Glin Castle, Co. Limerick* - Because of the unsettled state of Ireland during the sixteenth and seventeenth centuries, comparatively few items of furniture survive from that period.

One of the items which can still be seen, is the richly-carved table at Glin Castle. The carving is dramatic and strong in expression, and the grotesque animal face may be a throwback to earlier Celtic styles.

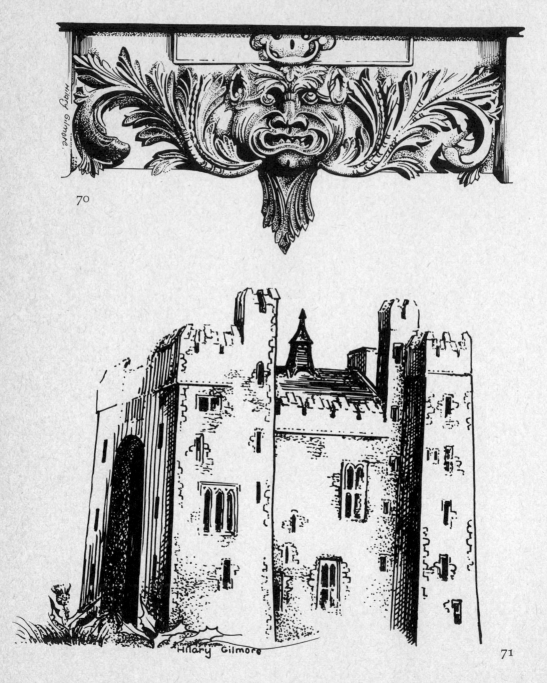

70

71

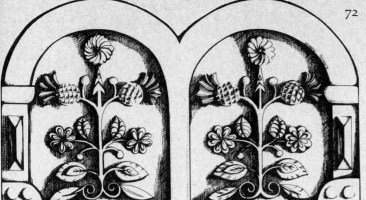

72

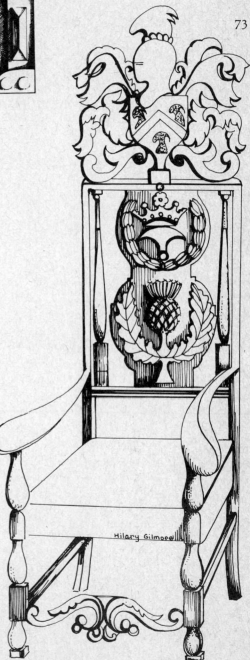

73

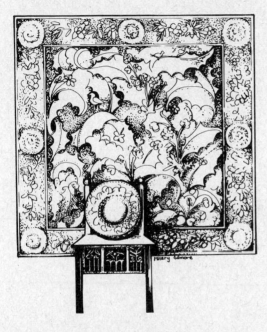

74

71-74 Furniture - *Bunratty Castle, Bunratty, Co. Clare* - The Bunratty site has been occupied since Viking times but the present castle was erected in the later fifteenth century. Around 1500 it was taken over by the O'Briens in whose family it remained. In 1954 the castle was bought by Lord Gort and was later restored and furnished to recreate the atmosphere of a sixteenth-century castle. It houses one of the best collections of fourteenth- to seventeenth-century furniture anywhere in Britain and Ireland.

Fig. 71 shows the castle exterior; fig. 72 shows two richly-carved panels from an Elizabethan bedhead; fig. 73 is a carved master's chair of a livery company. Two coats of arms and the thistle (national emblem of Scotland) are depicted; fig. 74 is a sixteenth-century tapestry woven with a design of flowers, birds and thistle-like leaves.

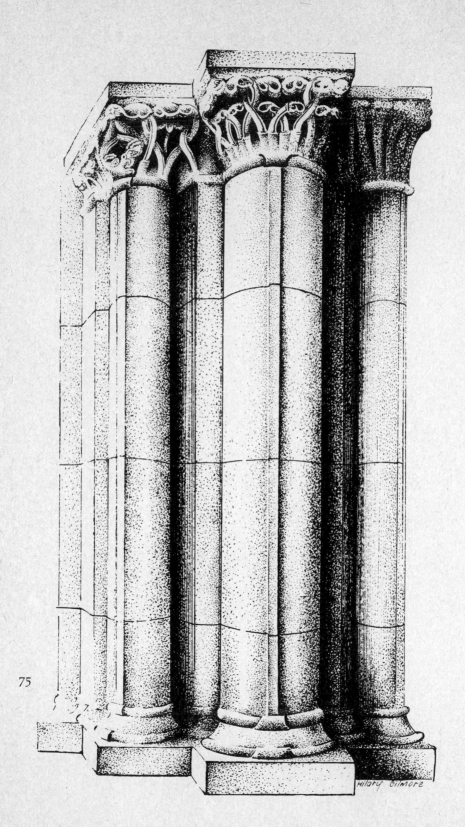

75

Hilary Gilmore

IRISH ART HERITAGE 48

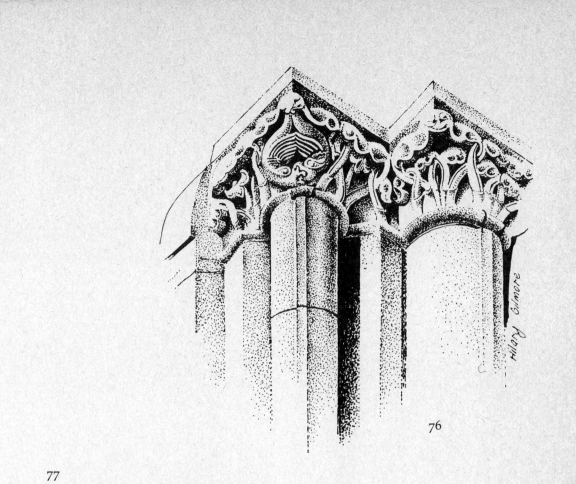

76

77

75-80 Items from Churches and Round Tower -
Kilmacduagh, Co. Galway - Kilmacduagh is situated
on the borders of Co. Galway and Co. Clare. It is a
monastic settlement dating from AD 600 and was
founded by St Colman. Remains of four mediaeval
churches and a fine round tower may be seen
there. The tower leans some three feet from the
perpendicular, and is an awe-inspiring sight on
the lake shore.

The O'Heyne's Church, built in the early thir-
teenth century, is noted for its beautiful chancel
arch, supported by pillars with animal and floral
decoration on the capitals. Fig. 75 shows the eleg-
ant tall pillars while fig. 76 shows details of the
capitals. Fig. 77 illustrates the base of the doorway.

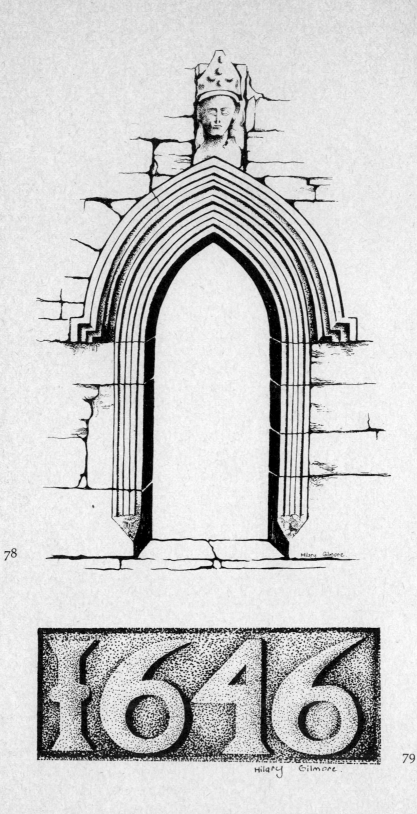

78

Hilary Gilmore

79

Hilary Gilmore

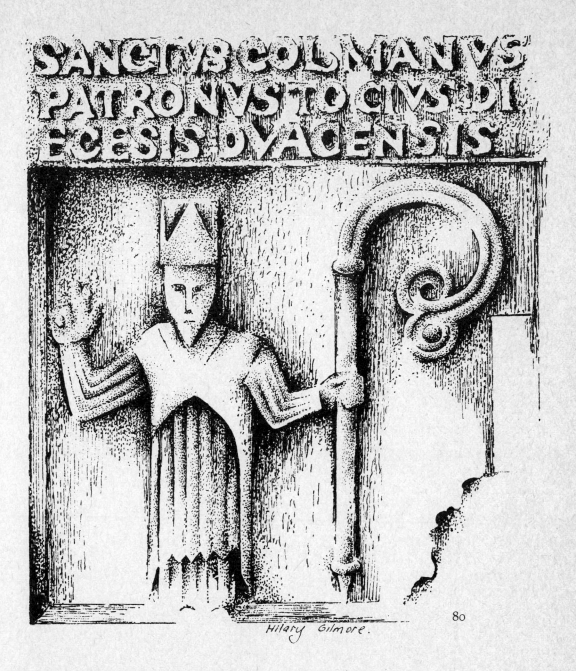

SANCTVS COLMANVS
PATRONVS TOCIVS DI
ECESIS DVACENSIS

Hilary Gilmore.

80

The cathedral or main church was begun in the twelfth century and subsequently received several additions. The example illustrated (fig. 78) is a fine doorway inserted in the south wall of the nave during the fifteenth century, with the carved head of a bishop above it. In the west wall of the north transept is a stone with beautifully carved lettering and numerals. The crisp numerals are illustrated in fig. 79.

Under the window of the eastern wall of the same transept is one of two sculptured slabs — a bishop with an ancient mitre and crozier, quaintly carved (fig. 80). It bears the following inscription, in slightly raised letters: 'Sanctus Colmanus Patronus tocius Diecesis Duacensis' ie St Colman, patron of the entire diocese of Kilmacduagh.

The Georgian Period

1714 - 1830

This is the period of Protestant ascendancy in Ireland. The upheavals and shifting fortunes of the seventeenth century had resulted in a society dominated by a landed élite. Secure in their control, they used this period of peace and prosperity to build new houses, plan new towns, erect public buildings and generally provide an environment where art and craft were given full rein. While the patrons were Anglo-Irish and the architects frequently English, the actual builders and craft workers who executed their plans were native Irish. The extent to which there existed a distinctive Irish art identity during this period is debatable. In many areas there was little specific Irish input, the styles being mere reproductions of English or European forms. Yet some distinctive Irish patterns were produced and even in the borrowings, individual craft workers put their own stamp on much of the work.

The production of delftware provides an interesting example of this development. The basic designs used were taken from English, Dutch and Chinese models, yet Irish delftware of the eighteenth century has a distinctive character. Many splendid specimens of this craft were produced, particularly those with painted landscape scenes.

Irish plasterwork received a major boost from the introduction of foreign craft workers during this period. The high-quality work produced in Ireland by the Francini brothers and others has tended to overshadow the considerable work produced by native craft workers. The main Italian influence was

the use of life-size human figures often with surrounding plasterwork of intricate detail executed in high relief. The native workers produced more delicate work, with scrollwork, fruit, flowers and birds being the most popular motifs.

Irish furniture reflected English style and taste for much of the period, but between 1730 and 1770 a distinctive Irish version of Adam-style furniture was manufactured. Dark mahogany wood tended to replace the more traditional oak. Carving of heads, masks, leaves, shells, birds and animals was popular on tables, cabinets and chairs. This fashion for heavy, detailed carving also extended to the legs of most furniture. The interest in heavy decoration is also seen on Irish silver. Flowers, birds and country scenes were the most common designs and were executed by the repoussé technique. Irish silversmiths produced a unique item in the dish ring, a large, highly decorated ring on which hot dishes could be placed. Silver sugar bowls and cream jugs of distinctive design were another feature of their work.

This period also produced the first Irish cut glass from Waterford and Cork between the 1780s and the 1820s. Initially, Irish glass was either cut or engraved with simple linear designs which later became much more intricate. Decanters, jugs, fruit bowls, punch bowls and candlesticks were the main items produced. Architecturally, the main development was the introduction of the Palladian style. This was an attempt to return to the fundamental classical designs of ancient Greece and Rome and a reaction against the corruption of classical models which had occurred. Palladianism was in turn replaced by neo-classicism, an even purer and more faithful reproduction of classical styles.

In sculpture, the main fashion was for the portrait bust, usually in neo-classical style. A notable exception to this trend was the sculptured sepulchral monument to Sir Donat O'Brien in Kilnasoolagh Church, Co. Clare. This unique work is in baroque style and is a notable Irish example of both a monument type and a style which eighteenth-century Ireland otherwise rejected.

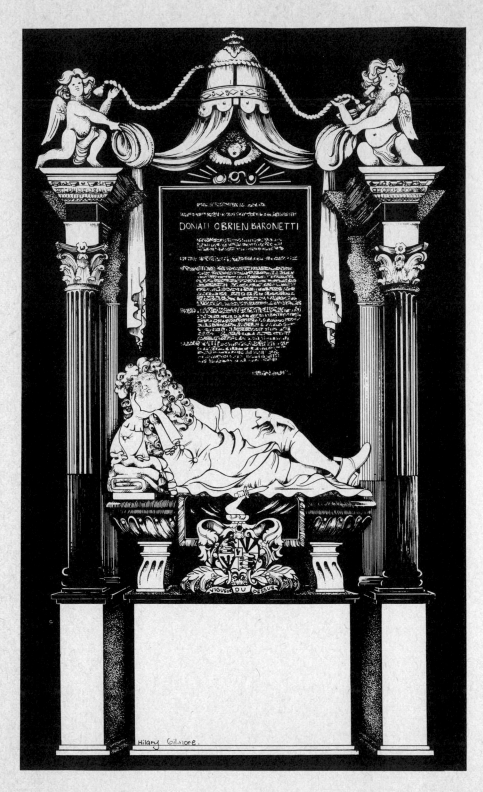

DONATI OBRIEN BARONETTI

VIGUEUR DU DESSUS

Hilary Gilmore.

81

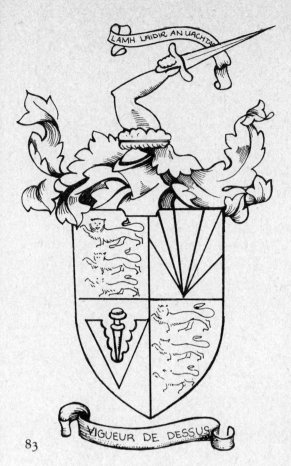

LAMH LAIDIR AN UACHTAR

VIGUEUR DE DESSUS

83

81-83 Monument to Sir Donat O'Brien - *Kilnasoolagh Church, Newmarket-on-Fergus, Co. Clare* - During the first half of the eighteenth century, sculpture in Ireland was almost entirely confined to architectural decoration. Sepulchral monuments were usually in the form of simple wall tablets rarely including figures. The fine baroque monument to Sir Donat O'Brien is an exception. It dates from 1717 and is by William Kidwell (1662-1736), an Englishman who worked on architectural pieces, fireplaces and door surrounds. One of his works can also be found above a garden door at Shannongrove, Co. Limerick.

Fig. 81 shows the fine monument in Kilnasoolagh Church; fig. 82 shows the wrought-iron gates which surround the monument; and fig. 83 shows the crest of the O'Briens.

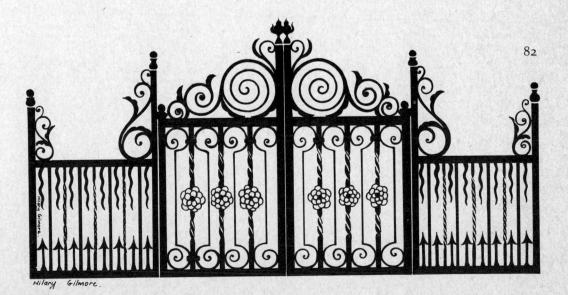

82

Hilary Gilmore.

84

84, 85 Plasterwork - *Carnelly House, Clarecastle, Co. Clare* - Carnelly House is a fine brick, three-storey house with stone dressing, window architraves, and a Venetian doorway. It was designed about 1740 by architect Francis Bindon, who specialised in the Palladian style.

The most striking feature of this house, built for the Stamer family, is the remarkable drawing-room in rococo style with heavy floral mouldings; fig. 84, entire ceiling; fig. 85, centre ceiling rose.

85

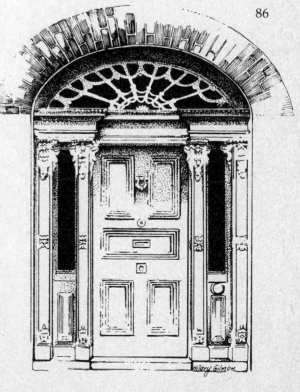

86

86-99 **Features of Georgian Houses** - *Limerick* -
Georgian features are still very much in evidence
in Limerick. Dignified and formal street elevations
as well as many quite exceptional building details
can be seen in many locations.

Development was undertaken within the
framework of a formal overall plan. This reflects
the vision and enlightenment of the right honour-
able Sexton Pery, who in 1769, had the streets laid
out by a skilled town planner, possibly Davis
Duchart, the designer of Limerick's splendid Cus-
tom House.

The skills of different trades have all contributed
to the overall effect. These include brickmakers,
stonecutters, stonemasons, wrought- and cast-
iron workers, carpenters, woodcarvers, plaster
workers, glaziers, painters and slaters.

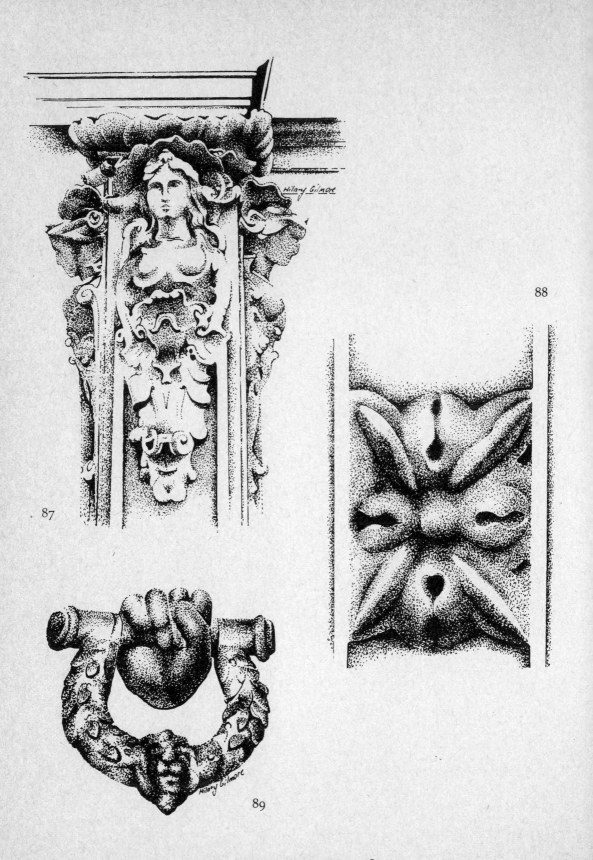

Hilary Gilmore

87

88

89

Hilary Gilmore

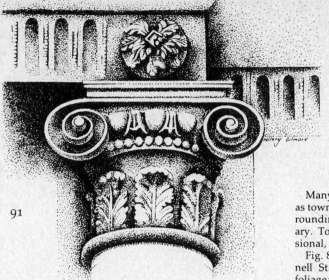

91

Many of Limerick's Georgian houses were built as town houses for landed gentry living in the surrounding counties of Clare, Limerick and Tipperary. Today, they are used primarily for professional, commercial and domestic purposes.

Fig. 86, a typical decorated doorway, 72 O'Connell St.; fig. 87 pillar detail, female head and foliage; fig. 88 flower detail; fig. 89 a cast-iron door knocker; fig. 90 doorway, 68 O'Connell St.; fig. 91 pillar detail, plumes and acorn, 68 O'Connell St.

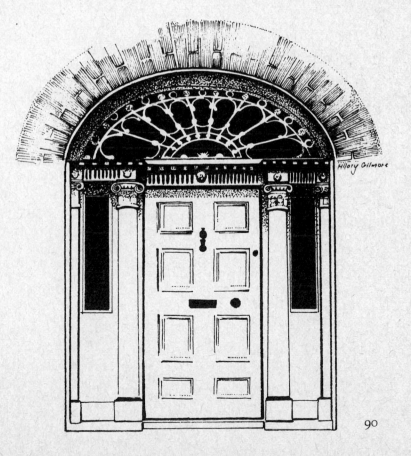

90

93

92

94

96

95

Fig. 92 railing detail, Upr O'Connell St and Crescent; fig. 93 cast-iron foot scraper, the Crescent; fig. 94 coal vault cover, Pery Square, shell ornamentation; fig. 95 coal vault cover, Mallow St.; fig. 96 coal vault cover, O'Connell St.; fig. 97 balcony detail, Pery Square; fig. 98 terrace, overall view, Pery Square; fig. 99 Georgian doorway, Ballingarry.

97

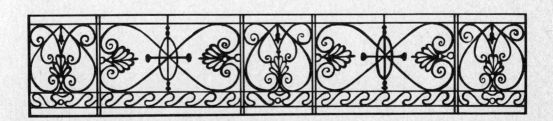

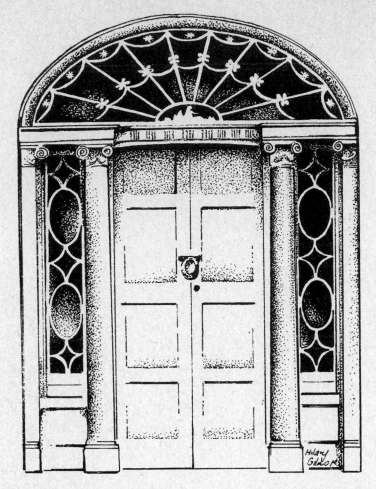

99

98

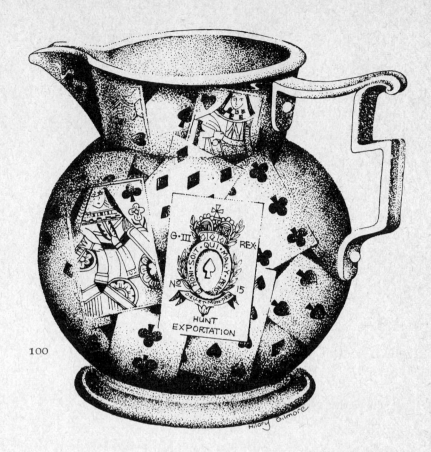

100

100 Pottery Jug - *Limerick* - There is no positive evidence available to confirm that pottery or ceramic work was undertaken in Limerick during the eighteenth century. However, a tenuous link can be established in the case of rather unique jugs, decorated with playing cards made in Lundy Island. Here a pottery was established by Sir Vere Hunt of Currachase, Co. Limerick. A jug of this type is illustrated here and one such jug may also be seen in Limerick City Museum.

101 Limerick-made Silver - *Limerick, Hunt Museum* - A number of renowned silversmiths practised their craft in Limerick during the seventeenth and eighteenth centuries. The families of Buck and Robinson were the most notable from 1660 to 1740, when the father-and-son partnership of Samuel and Joseph Johns came to prominence. The production of Limerick silver continued up to the famine of the 1840s. Some of this work may be seen in the Hunt collection at the National Institute of Higher Education, Plassey, Limerick.

A horn cup with silver mounts, shown here, made by John Purcell, is one of the finest pieces in the silver collection.

101

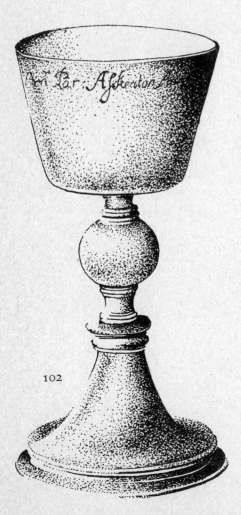

102

102 The Askeaton Chalice, Limerick Silver - *Co. Limerick* - The Askeaton chalice has a knob stem and reaches a height of 19cm. Inscribed on the upper part of the chalice are the following words: 'Ex do Somo Eaton Armt Par Askeaton Anno 1663'.

Marked with the Limerick castle and wavy star, it is probably the earliest dated piece of Limerick silver. The star mark has been found in many places within a radius of twenty miles around Limerick.

103 The Croom Chalice, Limerick Silver - *Parish Church, Croom* - This chalice with knob also bears an inscription: 'Ju usum Ecclesia de Crome Comonibus Parochiae Jinpenuis aro Domini 1699'. It is 27cm high with markings of the castle and star with monogram Jr. identical with Limerick Cathedral flagon.

104 Flagon, Dublin-made Silver - *St John's Church, Limerick* - This flagon has a lid and thumbpiece of entwined dolphins. It is inscribed as follows: 'The gift of Edward Sexton Pery, Esqr. to the Church of St. John, Limerick 1750'.

Marks: Dublin 1680-81 by John Phillips; J.P. in a boat-shaped shield over a five-petalled flower.

105 Mounted Polished Coconut, Limerick Silver - *Limerick* - This is an interesting polished coconut with silver mounts and feet which was made in Limerick around 1790.

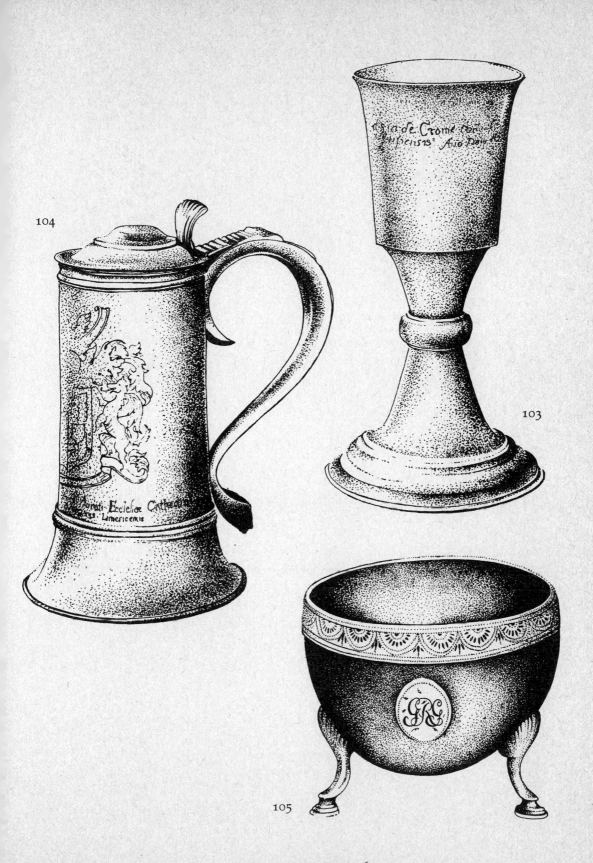

104

103

105

Victorian Period and Twentieth Century

1830 - 1930

The Act of Union, passed in 1800, moved the centre of political life in Ireland from Dublin to London. This development, followed by the Catholic Emancipation Act of 1829, sounded the death knell of the Irish Protestant nation which had been dominant in the eighteenth century. This narrow, unrepresentative Protestant nationalism was replaced by the Gaelic Catholic nationalism which was ultimately to triumph. Linked to the demand for political independence in this period was a renewed sense of national identity based on Ireland's Celtic past. The country's great cultural and artistic heritage was rediscovered, more fully appreciated and increasingly imitated. This process began in the 1830s, was intensified by the Young Ireland movement of the 1840s and came to its peak in the Irish renaissance from the 1880s onwards. The merging of this varied inheritance with Victorian tastes and values was not always successful but, overall, the Celtic revival produced an interesting phase in Ireland's complex artistic history.

Architecture flourished throughout the period. Public buildings such as courthouses, hospitals, gaols, workhouses and schools were erected extensively. Church building expanded rapidly, particularly Catholic churches in the aftermath of emancipation. Irish architecture tended to follow the fashion in England. Neo-classicism remained dominant in the early nineteenth century. A Gothic revival, particularly in church building, became fashionable thereafter, while Hiberno-Romanesque motifs were adopted under the influence of the

Celtic revival.

The popularity of classical and Gothic revival buildings inevitably benefited the craft of stone carving. The formal decoration of such buildings required skilled carvers, and while some English craft workers settled here, most of the carving was done by Irish workers. Tombstones also provided both a market and a challenge to stonemasons. While many brought patriotic harps, shamrocks and wolfhounds into the cemeteries, it was the ancient high crosses which provided the greatest inspiration and provoked the most imitation.

Plasterwork tended to be heavier and more ornate until the late nineteenth century, when methods of mass production caused a total decline in the craft. Both silver-working and glass production suffered a similar decline. Mass production, along with a slavish copying of English designs and public demand for very large, over-ornamented objects caused the deterioration in silver-work. Government duty after 1825 damaged the glass craft, though the influx of Bohemian glass engravers to Dublin helped maintain standards in the later nineteenth century.

The Celtic revival left its mark on furniture of the period. Harps, wolfhounds, shamrocks and round towers appear frequently as decoration, particularly on bog oak, which was a popular choice of wood. Such wood, literally dug up from turf bogs, was well seasoned and had acquired a rich warm colour. Similar motifs appear on inlaid furniture, also using bog oak. Killarney became an important centre for such work and gave its name to this type of inlaid furniture.

Bog oak was also used for jewellery and small souvenirs. This trend is reputed to have begun in 1821 when George IV was given a walking stick of bog oak as a gift during his Irish visit. Brooches, bracelets, necklaces, chess boards, and a multiplicity of other small ornaments were carved and eagerly bought by nineteenth-century visitors to Ireland.

The famine provided an unexpected revival for lace-making and crochet. Concerned ascendancy women and nuns saw these crafts as a useful source of employment for poor women, and undertook the teaching of these skills. Limerick and Carrickmacross became the main centres of lace production which

involved embroidery on manufactured net rather than total production with a needle as in point lace.

Perhaps the most notable artistic innovation of the period was Beleek porcelain made in Co. Fermanagh from the 1860s. Its delicacy, creamy glaze and well-modelled, naturalistic detail are particularly noteworthy. Originally, skilled workers from Stoke-on-Trent were used, but they soon trained local people. Designs from the Book of Kells were used as inspiration for new patterns but eventually, perhaps inevitably, shamrocks, harps and Celtic crosses came to predominate in this, as in so many other areas of art and craft.

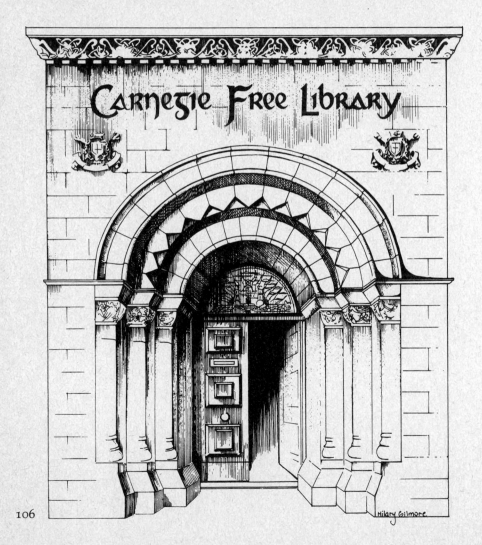

106

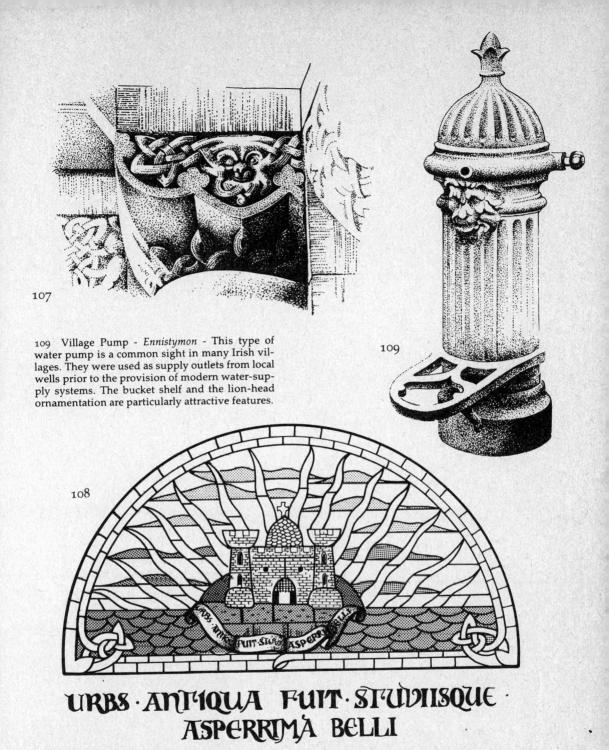

107

109 Village Pump - *Ennistymon* - This type of water pump is a common sight in many Irish villages. They were used as supply outlets from local wells prior to the provision of modern water-supply systems. The bucket shelf and the lion-head ornamentation are particularly attractive features.

109

108

URBS · ANTIQUA FUIT · STUDIISQUE · ASPERRIMA BELLI

106-108 City Library and Art Gallery - *Pery Square, Limerick* - This exceptional building, endowed by the Carnegie Trust was built in 1906 to the design of architect George Sheridan. The Hiberno-Romanesque/Celtic revival style was normally used for church buildings and its application to a secular building like the library is unusual. Six different carved capitals grace the doorway and the fan-light has a special quality. Fig. 106 shows the doorway with interlacing designs; fig. 107 shows a detailed drawing of one of the six different capitals; and fig. 108 shows the stained-glass fanlight with a sunset design, behind the Limerick coat-of-arms.

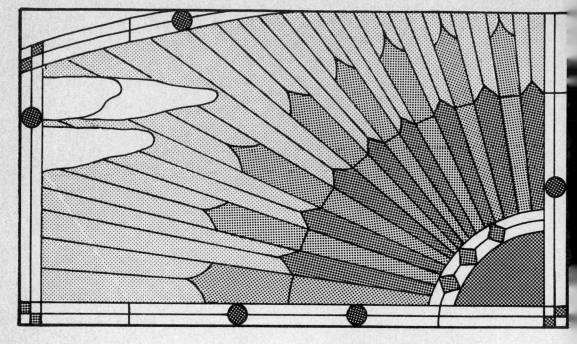

112

110, 111 Pulpit - *St Mary's Cathedral, Limerick* -
The pulpit was presented to the cathedral in 1860,
as a memorial to Archdeacon William Maunsell. It
is in three panels and made of Caen stone. The
centre panel depicts the 'Presentation at the tem-
ple', while the side panels, shown here, are carved
in arabesque foliage.

110

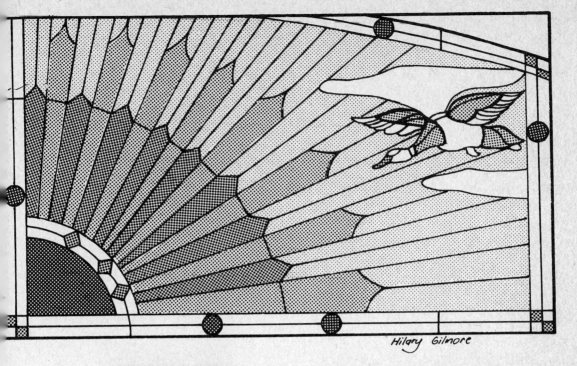

Hilary Gilmore

112 Stained-glass Window - *1 Broad Street, Limerick* - This interesting window made in the earlier part of the twentieth century is fitted in a licensed premises at the junction of Broad Street and Watermill Quay. The building was, until recent times, known as The Anglers Cot.

111

Hilary Gilmore

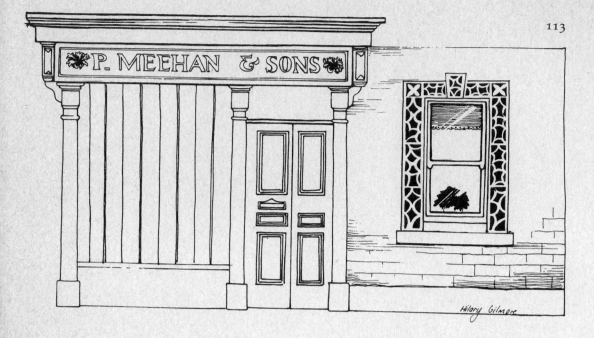

Hilary Gilmore

113-118 Shop Fronts and Signs - *Various Locations* - Many attractive late nineteenth and early twentieth century shopfronts still adorn towns and villages in the Mid-West to which they add both individuality and character. Tiles, wood carving, wrought and cast iron, and original styles of lettering were all used to varying degrees to enhance the shopfronts. Unfortunately, many of these materials are now being replaced by neon and plastic.

Some examples of these shopfronts are illustrated here: Fig. 113 shows a shopfront executed by P. Meehan and Sons, an Ennis family of decorators. It originally had twentieth-century vermiculation on the façade with gilded lettering and a floral design, behind glass. When it was altered in 1981, the gilded lettering was removed; fig. 114 illustrates attractive, painted, cast-iron lettering from a shopfront in Market Street, Ennis.

The shopfront has late nineteenth-century parallel raised quoins, lined rendering and architraves around the windows; fig. 115 depicts late nineteenth-century tiles in panels (half a panel illustrated here) adorning a butcher's shopfront in Kilkee. Though modernised, the shopfront still retains panels of mauve, ochre and other coloured tiles. The panels were imported from Scotland ninety years ago by the grandfather of the present owner; fig. 116 also shows tiles on a pillar in Ellen Street, Limerick, using subtle colours — pale green, ochre, white, brown and black; fig. 117, 3 Cornmarket Street, Ennis, has channelled gilded lettering behind glass, signed J. Keane, Ennis. The building was knocked down in October 1981 but the lettering and panel have been saved; fig. 118 represents blue and white tiles from a butcher's shop in Abbey Street, Ennis. The shop has been renovated and the tiles removed.

114

113a

115

Hilary Gilmore.

117

3 SEAN OFARRELL 3

J. KEANE ENNIS

Hilary Gilmore

116

118

120

119

119, 120 Details from Bank Premises - *Ennis, Co. Clare* - The Munster and Leinster Bank, now the Allied Irish Bank, was built in 1916, although in terms of style the cut-stone decoration could have been carved fifty years before. It was designed by the firm of Ashlin and Pugin in 1913.

It is built of red brick, with a ground floor of channelled ashlar limestone. Each of the five bays is divided by piers of parallel raised quoins with swags of flowers at the top, a frieze, cornice and blocking course. Fig. 119 shows a string course with rope moulding under the ground floor, and fig. 120 illustrates an air-vent made from cast iron.

121

121, 122 Limerick Lace - *Good Shepherd Convent, Limerick* - In 1829 the manufacture of lace commenced in Limerick. Charles Walker, a native of Oxfordshire, brought over twenty-two women as teachers and began manufacturing lace at Mount Kennet in Limerick City. This and a number of other lace-making establishments prospered in Limerick for a considerable time. Early in the twentieth century however, the trade declined and now only the Good Shepherd Convent continues the craft.

Limerick lace is worked in many different patterns and a rich variety of stitches is used. Some of these are: diamond, herringbone, two stitch, long knotting, flat-fining, seed stitch, star stitch, all darn, small knotting, cross-fining, bird's eye, web, into-every-mesh, and chapel stitch.

When one examines the gossamer-like quality of Limerick lace, its variety of stitches and beauty of design, it is easy to understand why a Limerick lace wedding veil, christening robe, luncheon set, or perhaps a stole for evening wear, are looked upon as heirlooms and treasured from one generation to the next. But perhaps the finest specimens are to be seen in the magnificent range of albs, rochettes, surplices and altar falls which have been supplied to churches all over the world.

Fig. 121 is a lace tray cloth and fig. 122 shows a table cloth.

122

123

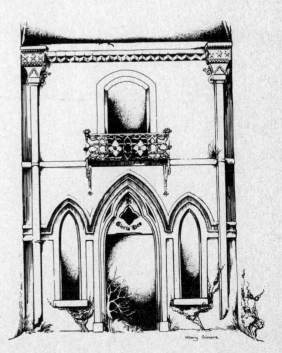

123-125 Paradise House - *Ballynacally, Co. Clare* -
In the past, many fine old houses of architectural
note graced the country, but sadly few now
remain. One house which survived until the 1970s
was Paradise House, Ballynacally, Co. Clare (fig.
123). The original house on the site, built in 1680,
was altered during Victorian times. Its design was
quite exotic and Turkish influence was apparent.
Many fine crests and pieces of wrought- and cast-
iron graced its walls.

Fig. 124, shows the remains of the main door-
way, with cast-iron details; while fig. 125 shows
the superbly designed gates of the family burial
grounds.

124

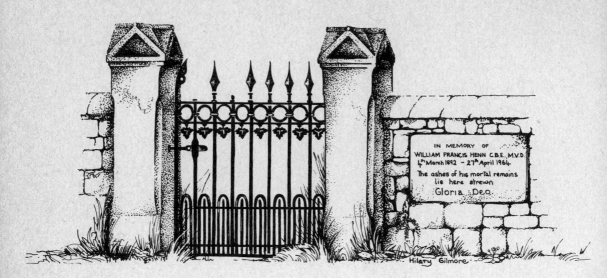

IN MEMORY OF
WILLIAM FRANCIS HENN C.B.E., M.V.O.
4ᵗʰ March 1892 — 27ᵗʰ April 1964
The ashes of his mortal remains
lie here strewn
Gloria Deo.

Hilary Gilmore

125

126 Capital Feature from Church of St Columba -
Bindon Street, Ennis, Co. Clare - This church was
built in 1871 and replaced the old abbey which had
been used for worship until that time. The church
contains many fine memorials to well-known Co.
Clare families. The decorative features include one
of a pair of fern-type capitals which are on each
side of the entrance porch.

127 Chimney Detail - *Adare Manor, Adare, Co.
Limerick* - This fine piece of stone detail is typical of
the ornate decoration applied to the manor
exterior. Construction commenced in 1831 at the
instigation of the second Earl (1782-1850) who pre-
pared the initial design. He was influenced by
contemporary Victorian fashions in architecture
which prompted designers to include a wide range
of elements from previous architectural eras. Two
eminent nineteenth-century architects, Pugin and
Hardwick, also undertook design work on the
manor.

Hilary Gilmore

126

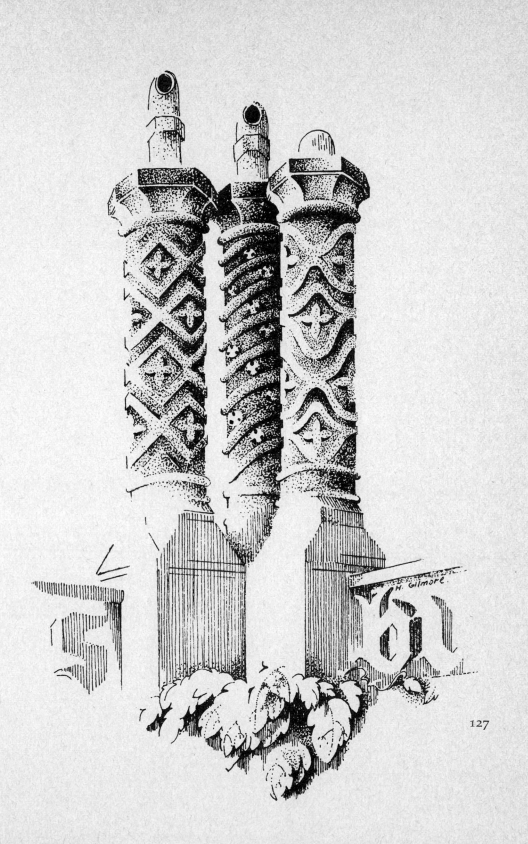

127

128

Hilary Gilmore.

129

Hilary Gilmore.

128-134 Wrought and Cast Ironwork - *Various Locations* - The Mid-West is well endowed with wrought- and cast-ironwork. There is an infinite variety of designs used for balconies, piers, railings, gates, pumps, verandas, and so on. The designers of cast-iron derived their patterns from many sources and the leading manufacturers of ironwork during this period were Harrison, Lee and Sons of Limerick.

Some fine examples are illustrated. Figs. 128, 129 and 130 show railings on O'Connell Avenue, Limerick; fig. 131 is a fine cast-iron gate also in O'Connell Avenue; while fig. 132 shows the gates of the old Potato Market, Limerick, with its interesting pillars; in fig. 133 the wrought-iron gates in front of the Catholic Church at Crusheen, Co. Clare, which were made in O'Donnell's foundry, Limerick, are illustrated; fig. 134 depicts altar rails at the Wells Church near Newmarket-on-Fergus, made by father and son, Ned and Tom Fitzgerald.

130

Hilary Gilmore

132

133

134

Folklife

The industrial revolution, which brought about the death of so much local craftwork, came late to Ireland and allowed the phenomenon of local self-sufficiency to last longer here than elsewhere. Even in this century, before mechanisation and mass production took over, the small farming communities of Ireland satisfied their material needs for furniture, implements and tools largely through their own work, but supplemented by the services of a small number of specialist workers. These specialists might come from the community, or where the volume or frequency of work available within any district would not support a resident craft worker, the work might be carried out by an itinerant. Within the local community, specialist workers were held in high esteem, particularly the blacksmith. Curiously, the travelling craftworkers, whether they were weavers, tailors or tinkers, tended to be despised especially by the farmers who saw them as socially inferior and distrusted them intensely. These talented and indispensable workers achieved at best a grudging toleration, based solely on their craft.

This regrettable attitude may, to a certain extent, account for our failure as a nation to appreciate the value of objects which were made and used every day by the majority of people. It has been suggested that peasant people tend to regard such objects as symbols of poverty and as all-too-vivid reminders of a past they would prefer to forget. Understandably, there is also the inability to appreciate fully that items which are familiar and

mundane can be works of excellent design and craftsmanship.

This general attitude is coupled with the virtual dominance, over the last twenty years, of mass-produced objects frequently made of plastic. Because of this, young people often regard the surviving items of Irish folklife as belonging to a period which they consider as remote and meaningless as the Middle Ages or even pre-historic times. Little effort has been made to preserve – let alone value or cherish – this part of our heritage. Most of the items made by these craft workers reached standards of excellence unlikely to be repeated today. They were executed in wood and other perishable material, and many have been lost due to the ignorance or apathy of their owners.

The State and academic institutions have to take some of the blame also. Folk museums, long established and recognised as invaluable in Scandinavia, are still in their infancy in Ireland. Bunratty Folk Park is an honourable and valuable exception, and its collections are thus of great importance in preserving and exhibiting a major part of the craft and design heritage of Ireland. A study of folklife material shows particularly the over-all cultural unity in shape, pattern and style, while also demonstrating fascinating modifications and adaptations pro-duced in different regions.

135 Grave Slab - *Dysert O'Dea, Corrofin, Co. Clare* - Local stonemasons displayed considerable skill and imagination in their work on grave slabs. This slab is a relatively simple stone monument dated 1883, with an attractive and skilfully-executed overall design which includes an ornate cross and shamrocks.

135

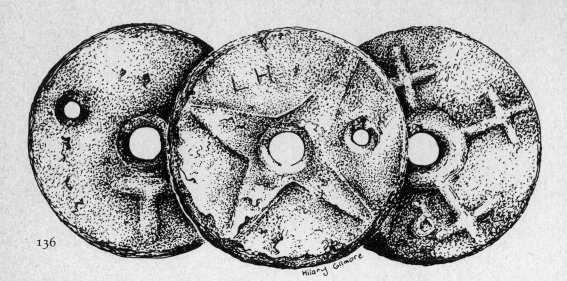

136

Hilary Gilmore

137

136 Rotary Querns - *Various Locations* - Hand
milling dates back to pre-historic times but con-
tinued into the early twentieth century. Hand
mills as used in Ireland can be divided into the fol-
lowing categories: bullaun stones; pot querns;
saddle querns; rotary querns.

Fig. 136 shows three examples of querns found
at Liscannor, Co. Clare. The star and cross patterns
as well as the mason's initials 'L H' are of interest.

137-141 Domestic Items and Farm Equipment -
Bunratty Folk Park, Co. Clare - Self sufficiency
dominated Irish rural life up to the early part of the
twentieth century. Rural dwellers grew most of
their own food, and nearly all of the equipment
used on the farm or in the house was made by local
craft workers or by people in adjoining small
towns.

The designs used in steel and cast-iron items
were simple and functional. Fig. 137 is a simple
form of dash churn found along the west coast; it
terminates in a wooden cross. Fig. 138 is a
nineteenth-century 'new metropolitan' washing
machine now in the Golden Vale cottage, Bunratty
Folk Park. Fig. 139 shows an oven pot on a trivet,
an iron frying-pan and a bread-iron. These are also
in the Golden Vale cottage at Bunratty Folk Park.
Fig. 140 is a cooking pot with a decorated lid, a
common kettle and tongs. Fig. 141 is a plough.

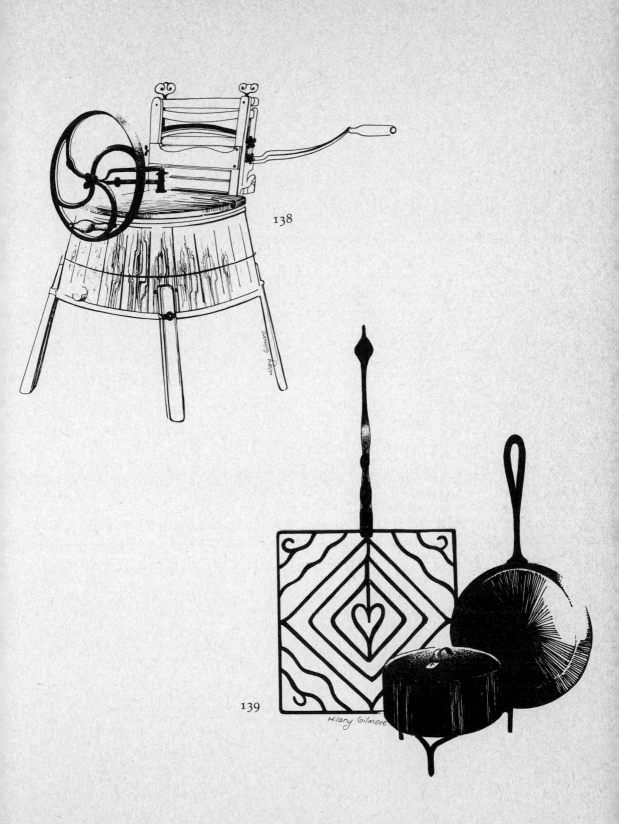

138

139

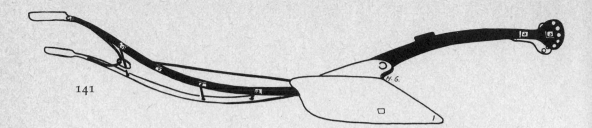

141

142

140

142 Table Tomb - *Quin Abbey, Quin, Co. Clare* -
To the east of the cloister in Quin Abbey is a long
room (approx. 71′ x 12′) probably used originally as
a refectory. On the floor of this room is a series of
large table tombs showing a great variety of
designs. They appear to be the work of the same
stonemason.

 Illustrated here is one of the table tombs display-
ing a wide variety of lettering, religious symbols,
natural and geometric patterns.

Plant Sources

In any consideration of Ireland's heritage, the flora of the country must be given a prominent place. This feature is no less priceless and worthy of appreciation and preservation than the architecture, artwork, metalwork and sculpture. There are roughly one thousand species of flowering plants and ferns native to Ireland.

In Munster we have two areas which rank as major European botanical regions. The highland areas of Cork and Kerry are noted for a particular type of flora, termed Lusitanian by botanists, from its origin in Iberia. The Burren area of Co. Clare, on the other hand, is famous for its diversity. In this region, acid-loving and lime-loving plant species grow together successfully as do Arctic-Alpine and Mediterranean flora, a combination which is unique in Europe. Scientists have been unable to fully explain why this unusual situation occurs. The successful growth of plants from cold northern areas along with those from the warmer southern regions remains the tantalising secret of the Burren itself. The Gulf Stream, absence of frost and the carboniferous limestone are clearly key factors in their survival. Among the Arctic plants the most notable are the spring gentians which flower in April, May and June, with their five characteristic deep blue petals. Another distinctive Arctic-Alpine species is the mountain aven with white petals which radiate from yellow stamens at its centre.

It is not surprising that artists and craft workers were influenced by this unique environment. Designers throughout the

ages have used nature as a source of inspiration and imitation. The work of stonemasons illustrated here, who copied and adapted much of the unique flora of the Burren, provides a fascinating example of this influence of environment on art.

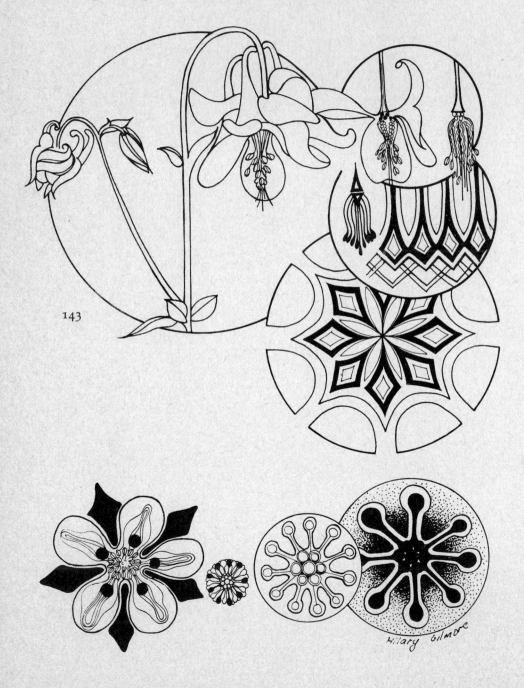

143

144

143-147 Plants - *Various Locations* - Many of the
subjects illustrated in this book indicate that
nature has had considerable influence on craft
workers. An infinite variety of designs and forms
can be produced from one plant by viewing it from
different angles. Fig. 143 shows an *Aquilegia vul-
garis* (common columbine) which illustrates this
point. The columbine is a native of limestone rocks
and a common garden plant. Illustrated also is the
Carlina thistle (fig. 144), spring gentian (fig. 145),
Burnet rose (fig. 146) honeysuckle (fig. 147).
 The famous Burren of Clare is a designer's
paradise and a great source of inspiration. One
does not even have to go as far as the Burren to see
plants which have influenced craftwork. The
illustration of thistles (fig. 144) recalls their use as
a design source for the silver-gilt thistle brooch
found near Ardagh, Co. Limerick (fig. 11).

145

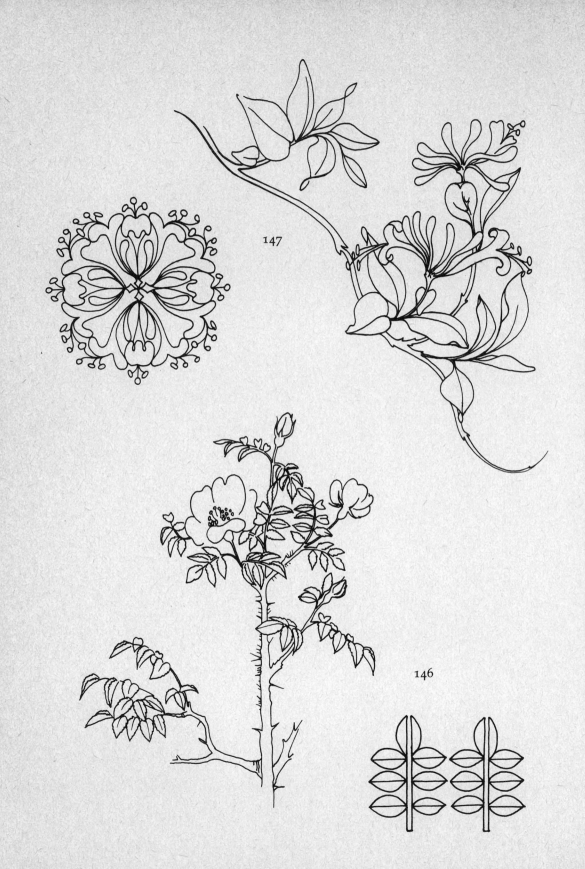

147

146

Designs inspired by plant and flower motifs:

EARLY CHRISTIAN ERA

Fig. 28 carving inspired by bluebell, p.27

Fig. 30 floral carving perhaps inspired by water avens or harebells which grow in the area, p.27.

Fig. 31 flower head details on section of doorway — similar flower head on window of Clare Abbey, p.28.

Fig. 34 slab bearing floral patterns and four-leaved flower on base, p.29.

Fig. 35 foliar decoration above east window, p.29.

Fig. 37 foliar inspired panel on side of doorway, p.30.

Fig. 41 floral pattern on cross, p.31.

MEDIAEVAL

Figs. 47-53 a wealth of naturalistic carvings of wild flowers and leaves, p.36-37.

Fig. 59 foliar carvings on panel, p.40.

Fig. 61 foliar carving on misericord, p.41.

Fig. 63 foliar capitals, p.41.

Fig. 64 foliar carved detail on pillar, p.42.

Fig. 66 exterior window with foliar detail, p.43.

Figs. 67-69 enamelled and inscribed patterns of vine stalks with foliage and flowers on the Limerick crozier, p.44.

Fig. 73 floral and foliar inspired carvings; thistle carving on chairback, p.47.

Fig. 77 foliar detail on base of doorway, p.49.

GEORGIAN

Fig. 82 wrought iron gates with flower head type decoration, p.55.

Figs. 84-85 ceiling with arabesque patterns in plaster-work, p.56-57.

VICTORIAN & 20th CENTURY

Figs. 110-111 panels of arabesque foliage, p.70-71.

Fig. 113 use of stylised leaf shapes, p.73.

Fig. 115 shopfront tiles with foliar designs and fleur-de-lis, p.73.

Fig. 116 pillar, Ellen Street, Limerick, with flower-head motifs, p.74.

Fig. 118 blue and white tiles with foliar-type design, p.74.

Fig. 119 string course with rope moulding and leaf carving, p.75.

Figs. 121-122 obvious use of floral and leaf motifs for tray cloth and table cloth, p.76.

Fig. 124 flower and shamrock details on balcony iron work and drainpipes, p.77.

Fig. 125 gates with realistic leaf iron work, p.78.

Fig. 126 fern-type capitals each side of entrance porch, p.78.

Fig. 130 leaf-inspired wrought iron railings, p.81.

Fig. 133 shamrock-type design on points, p.83.

Fig. 134 flower heads on altar rails, p.83.

FOLKLIFE

Fig. 135 use of shamrock in over-all designs, p.85.

Fig. 142 stylised flower patterns, leaves and fleur-de-lis, p.88.

APPENDIX

Suggested Applications of Design Material

CRAFT MATERIALS	TECHNIQUES	EXAMPLES OF PRODUCTS
Paper	Litho, letterpress, screen printing, hand lettering, linocuts, etching.	Posters, prints, books, wallpaper, signs, postcards.

Glass	Blowing, cutting, engraving, etching, sand blasting.	Tableware, windows, mirrors.
Leather	Embossing, burning, lacing, carving, inlaying.	Purses, wallets, belts, handbags, clothing, bookbinding.
Metals (precious and semiprecious: gold, silver, copper, brass, bronze, stainless steel, pewter, etc.)	Working, casting, engraving, polishing, spinning, enamelling.	Jewellery, tableware, cutlery, plaques, trophies, religious items, coins, medallions.
Ceramics / pottery / enamel	Coiling, moulding, turning, glazing, painting, hand modelling.	Tableware, vases, plaques, tiles, statues, figurines.
Wood	Shaping, turning, carving, inlaying, engraving, polishing.	Furniture, plaques, trophies, nameplates, lamp fittings, bowls, picture framing.
Textiles	Spinning, weaving, dyeing, printing, cutting, sewing, knitting, crochet, batik, embroidery, felting, macrame.	Fashion wear, tapestries, rugs, batik, hangings, house furnishings.
Marble	Sculpting, mosaic work.	Statues, plaques, trophies.
Wax	Moulding	Candles, plaques.

A range of selected applications is summarised above. Possible applications of the visual concepts illustrated in this publication are virtually unlimited. Limitations, if they exist at all, will be confined to the suitability of raw materials and the imagination of craft workers and designers.

It is intended that the scope of application will not be confined to individually-made souvenirs, and that, in due course, the concepts now being proposed will be applied also to mass-produced items such as tableware, linen, furnishings, books, posters, etc.

While traditional techniques are likely to be used in the majority of cases, it is hoped that crafts people will also introduce new technology to their work such as new moulding materials and the use of laser beams.

Glossary

Abacus - upper member of capital supporting architrave.

Arabesque - decoration in colour or low relief, with fanciful intertwining of leaves, scroll-work.

Architrave - also called epistyle; main beam resting immediately on the abacus or capital of column; various parts surrounding

doorway or window; moulding round exterior of arch.

Ashlar - square-hewn stone(s); masonry constructed of this.

Chevron - bent bar of inverted V shape.

Champlevé - enamel in which the colours are filled into hollows made on the surface.

Chequers - patterns made of squares or with alternating colours.

Cloisonné - enamel in which colours of pattern are kept apart by thin outline plates.

Damascene - object in metal, usually steel, with inlaid gold or silver, ornamented with watered pattern produced in welding.

Escutcheons - heraldic shield; keyhole cover.

Flange - projecting flat rim collar or rib.

Fleur-de-lis - iris flower, heraldic lily.

Niello - black composition for filling engraved lines in silver or other metals.

Ogee - (moulding), showing, in section, a double continuous curve, concave below passing into convex above (S-shaped).

Piscina - fish pond, ancient Roman bathing pond; perforated stone basin in church for carrying away water used in rinsing chalice.

Pointillism - method of producing light effects by crowding a surface with small spots of various colours which are blended by the eye.

Quinhy - (Cuinche - the Arbutus grove) the strawberry tree, belonging to the heath genus, native of south west Ireland (15' to 20' high). Quin is said to have been named after this plant.

Repoussé - ornamental metal work hammered into relief from reverse side.

Rhomb (rhombus) - oblique equilateral parallelogram - as ace of diamonds on playing-card - object or part of such outline.

Samprey - eel-like pseudo-fish with sucker mouth, pouch gills and seven spiracles on each side with fistula on the top of the head.

Sedilia - set of three stone seats for priests in south wall of chancel often canopied and otherwise decorated.

Friquetra - symmetrical ornament of three interlaced areas.

Vermiculation - a method of finishing stonework giving it a wormy appearance, a kind of rustication.

Voussoirs - each of the wedge-shaped stones forming an arch.

Zoomorphic - dealing with or represented under animal forms; gods of beast-like form.

Bibliography

Arnold, Bruce, *A Concise History of Irish Art* (London 1977).

Bain, George, *Celtic Art, Its Methods and Construction* (London 1981).

Begley, Rev. John, C.C. *The Diocese of Limerick, Ancient and Mediaeval* (Dublin 1900).

Bennett, Douglas, *Irish Georgian Silver* (London 1972).

Carville, Geraldine, *Heritage of Holy Cross* (Belfast 1973).

Coffey, George, *Guide to the Celtic antiquities of the Christian Period Preserved in the National Museum Dublin* (Dublin 1910).

Craig, Maurice, & Knight of Glin, *Ireland Observed* (Cork 1970).

Craig, Maurice, *Irish Bookbindings* 1600-1800 (London 1954).

Crawford, H. S., *Handbook of Irish Carved Ornament from Monuments of the Christian Period.*

Crookshank, Anne, & Knight of Glin, *The Painters of Ireland* 1660-1920 (London 1978).

Danaher, Kevin, *Ireland's Vernacular Architecture* (Cork 1975).

De Breffny, Brian, & Ffolliott, Rosemary, *The Houses of Ireland* (London 1975).

De Breffney, Brian, & Mott, George, *The Churches*

and Abbeys of Ireland (London 1976).

de Paor, Liam, & de Paor, Máire, *Early Christian Ireland* (London 1958).

Doran, Dr Patrick, 'The Hunt Museum', *North Munster Antiquarian Journal* Vol XX (Limerick 1978).

Dowd, Rev. James, *History of St Mary's Cathedral, Limerick* (Killarney 1957).

Dwyer, Rev. Philip, *The Diocese of Killaloe from the Reformation to the 18th Century* (Dublin 1978).

Evans, Estyn, *Prehistoric & Early Christian Ireland. A Guide* (London 1966).

Fahey, Mons John, *The History & Antiquities of the Diocese of Kilmacduagh* (Dublin 1893).

Garner, William, *Ennis*, Architectural Heritage, An Foras Forbartha National Heritage Inventory (Dublin 1981).

Guinness, Desmond, & Ryan, William, *Irish Houses & Castles* (London 1971).

Harbison, Peter, 'Twelfth & thirteenth century Irish Stonemasons in Regensburg (Bavarian)' *Studies* (Dublin 1975).

Harbison, Peter, *Guide to the National Monuments in the Republic of Ireland* (Dublin 1970).

Hayes MacCoy, G. A., *A History of Irish Flags from earliest times* (Dublin 1979).

Henry, Francoise, *Irish Art in the Early Christian Period (to 800 AD)* (London 1965).

Henry, Francoise, *Irish Art in the Romanesque Period 1020-1170 AD* (London 1970).

Herity, Michael, & Eogan, George, *Ireland in Prehistory* (London 1977).

Hickey, Tomas, 'The Kilkenny Design Workshops', *The Arts in Ireland* 1 No. 3 (Dublin 1973).

Hughes, Kathleen, and Hamlin, Ann, *The Modern Traveller to the early Irish Church* (London 1977).

Hunt, John, 'The Limerick Cathedral Misericords' *Ireland of the Welcomes* (Dublin 1971).

Kaj, Franck, and others (Scandinavian Design Group), *Design in Ireland* (Dublin 1961).

Killanin, Lord, and Duignan, Michael, *Shell Guide to Ireland* (London 1967).

Knight of Glin, The, *Irish Furniture* (Dublin undated).

Leask, Harold G., *Irish Churches & Monastic Buildings*, 3 Vols (Dundalk 1955-1960).

Leask, Harold G., *Irish Castles* (Dundalk 1941).

Lenihan, Maurice, *Limerick: its history and antiquities* (Dublin 1866).

Longfield, Ada K., *Guide to the Collection of Lace in National Museum of Ireland* (Dublin 1970).

Lucas, Anthony T., *Treasures of Irish Pagan and early Christian Art* (Dublin 1973).

Macalister, R. A. S., 'History of Inis Cealtra', *Proceedings of the Royal Irish Academy* Vol XXXIII Section C No. 6 (Dublin 1916-1917).

Macalister, R. A. S., 'On a Runic Inscription at Killaloe' *Proceedings of the Royal Irish Academy XIII* (Dublin 1917).

MacAnna, Proinsias, *Celtic Mythology* (London 1970).

McCrom, S., *Belleek Pottery* (Belfast 1972) Ulster Museum Pub No. 188.

Mahr, Adolf, *Ancient Irish Handicraft* (Limerick 1939).

Merne, John G., *A Handbook of Celtic Ornaments* (Cork 1977).

Mitchell, Frank, Harbison, Peter, de Paor, Liam, de Paor, Máire, Stalley, Roger, *Treasures of Irish Art 1500BC to AD1500* The Metropolitan Museum of Art (New York 1977).

Murphy, Seamus, *Stone Mad* (London 1966).

Newman, Jeremiah, Most Rev. Dr, Bishop of Limerick, Address Opening of Treasures of Thomond Exhibition, (Limerick 1981).

O'Neill, Timothy P., *Life & Tradition in Rural Ireland* (London 1977).

O'Riordain, Sean P., *Roman Material in Ireland*.

Palliser, Bury, *A History of Lace* (Dublin 1902).

Potterton, Homan, *Irish Church Monuments 1570-1880* (Belfast 1974).

Sheehy, Jeanne, *The Rediscovery of Ireland's Past - The Celtic Revival 1830-1930* (London 1980).

Stalley, Roger, *Architecture and Sculpture in Ireland 1150-1350* (Dublin 1971).

Stokes, Margaret, *Early Christian Art in Ireland* (Dublin 1928).

Strickland, Walter G., *Dictionary of Irish Artists* (Dublin & London 1913).

Talbot, Dean Michael J., *A Pictorial Tour of Limerick Cathedral* (Limerick undated).

Talbot, Dean Michael J., *St. Mary's Cathedral, what to see*, (Limerick 1953).

Ticher, Kurt, *Irish Silver in Rococo Period* (Shannon 1972).

Westropp, Thomas J., 'Ennis Abbey and the O'Brien Tombs' *Journal Royal Society of Antiquities of Ireland* (1895).

White, James, & Wynne, Michael, *Irish Stained Glass* (Dublin 1963).

Wilde, William Sir, *Catalogue of Irish Antiquities* (Dublin 1860).

Wynne, Michael, *Irish Stained Glass* (Dublin 1977).

JOURNALS

'The Other Clare', various issues; 'The Irish Georgian Society', various bulletins.

OTHER PUBLICATIONS

'Church Disestablishment 1870-1970, A Centenary Exhibition', Catalogue (Dublin 1970).

'Craft Hunters Pocket Guide', Bord Fáilte (Dublin 1982).